097599

D1240976

Contents

Lenders to the Exhibition

ACME., Los Angeles

Arena Editions, Guadalajara

Lillian Ball

Dan Bernier Gallery, Los Angeles

Bravin Post Lee, New York

Cirrus Editions, Los Angeles

D'Amelio Terras, New York

Dia Center for the Arts, New York

Feigen Contemporary, New York

Marc Foxx, Los Angeles

Thomas Glassford

Jay Gorney Modern Art, New York

John McCracken

Mark Moore Gallery, Santa Monica

Rena Conti and Dr. Ivan Moskowitz

Eileen and Peter Norton

Melanie Smith

Hills Snyder

Jessica Stockholder

George Stoll

Chromaform

Color in Sculpture

Frances Colpitt

UTSA Art Gallery
The University of Texas at San Antonio

Distributed by the University of Washington Press

This publication accompanies the exhibition *Chromaform: Color in Sculpture,* organized by the UTSA Art Gallery at the University of Texas at San Antonio.

Exhibition Itinerary

UTSA Art Gallery
San Antonio, TX
3 September - 16 October 1998

University of North Texas Art Gallery
Denton, TX
5 November - 12 December 1998

Nevada Institute for Contemporary Art
Las Vegas, NV
8 April - 23 May 1999

University Art Gallery
New Mexico State University
Las Cruces, NM
12 June - 12 August 1999

University Art Gallery
Sonoma State University
Rohnert Park, CA
11 November - 17 December 1999

Edwin A. Ulrich Museum of Art
Wichita State University
Wichita, KS
21 January - 7 March 2000

Mount Holyoke College Art Museum
South Hadley, MA
7 April - 30 June 2000

Traveling exhibition arranged by Pamela Auchincloss, Arts Management

Catalogue designed by Martelle Design
Printed by Pearl River Printing Company Limited, Hong Kong

Distributed by the University of Washington Press
Box 50096, Seattle, WA 98145

ISBN 0-9640911-1-9
Copyright © UTSA Art Gallery, The University of Texas at San Antonio

This catalogue is made possible by the generous support of the Elizabeth Firestone Graham Foundation.

Acknowledgments

This exhibition, catalogue, and tour are the result of many years of planning and development by students, faculty, and administrators at the University of Texas at San Antonio. I am grateful for the support of Jim Broderick, Director of the Division of Visual Arts; John Vander Weg, Associate Dean for Graduate Studies and Research; and Alan Craven, Dean of the College of Fine Arts and Humanities. The UTSA Art Gallery staff, Director Ron Boling, Jennifer Diaz, and John Hooper facilitated the intricacies of mounting this complex exhibition. Student curatorial assistance was provided by Joseph Morales and Michele Monseau during the planning stages. Andréa Caillouet graciously contributed to the catalogue design. The graduate students in my Art Gallery and Museum Practices seminar provided not only the insightful essays and artists' biographies and bibliographies in the catalogue but organizational assistance as well. I hope they know how significant and appreciated their contributions and moral support have been.

Pamela Auchincloss, Alexandra Muse, and Jeremy Adams of Pamela Auchincloss, Arts Management organized the exhibition's tour with great finesse, diligence, patience, and unwavering enthusiasm. Along with viewers at the many institutions where the exhibition will be seen, we express our gratitude for their efforts. Carol Potter of Martelle Design has produced a stunning catalogue, and was, as always, an amiable collaborator. We also appreciate consultations with designer Chuck Ramirez. I would like to thank Jean Colpitt and Connie Lowe for their editorial advice and Don Walton for his good natured support.

Our deepest gratitude is extended to the artists participating in the exhibition. Each and everyone of them has been exceedingly generous, willing to respond to our many frequent inquiries, and forthcoming with their very best work. Their galleries, directors, and assistants have been equally and cheerfully cooperative. Special thanks go to Marc Foxx, Bob Gunderman, Christopher Ford, Peter Goulds, Jay Gorney, Rodney Hill, and Bill Begert and Gwen Hill of the Norton Family Foundation. Randy Sommer's advice, on which I can always depend, was solicited from the exhibition's inception and I am very grateful for it.

Finally, the exhibition and its catalogue would not have been possible without the support of the Elizabeth Firestone Graham Foundation. The Foundation's enthusiasm for the project, and particularly its educational component, has been a sustaining factor. — F.C.

Color and Sculpture: A Capricious Affair
by Frances Colpitt

In its exhilarating rebound into three dimensions, color is asserting itself with a forcefulness not seen since the 1960s. The sculptures in *Chromaform: Color in Sculpture* are not merely colored but *of* and *about* color as much as they are about materials and space, the more traditional concerns of sculptors. The formal issues that were basic to the color-happy sixties continue to prevail, now supplemented by a brazen embrace of the real world. Implicating the body, decoration, and artifice, the new sculpture is playfully mutant and powerfully seductive in its flirtatious use of color.

It is not only color but sculpture itself that has enjoyed a revival. Prior to the 1960s, the domination of painting over sculpture was summed up by Ad Reinhardt's infamous definition of sculpture as something you bump into when you back up to look at a painting.[1] Other than Rodin, the leading sculptors of the modern period are hardly household names; in fact, many innovations in sculpture were due to painters or former painters. Edgar Degas anticipated the phenomenon of assemblage in our century in his *Little Dancer* (1881), formed out of wax and clothed in a real ballet costume with a wig, hair ribbon, and shoes. Picasso was responsible for introducing the techniques of construction, as an alternative to modeling and carving, and welding, which proliferated at mid-century. Pursuing Picasso's innovations, David Smith was considered the most powerful and influential sculptor of his time, although he too had begun as a painter and did not think of himself as a sculptor until after he had been working in three dimensions for some time.[2] With backgrounds in painting, Degas, Picasso, and Smith were also among the most experimental with color in sculpture, whereas true sculptors, such as Constantin Brancusi and

Henry Moore, shied away from polychromy.

Historically, the proliferation of polychrome sculpture is sporadic in Anglo-European art, although almost all other civilizations, including Pre-Columbian, Latin American, and Asian, can claim a rich tradition of painted sculpture. Westerners are practically unique in their preference for uncolored forms. During the Renaissance and Baroque periods, the last era in which sculpture's prominence was equal to painting's, major monuments were uncolored almost without exception. As Andreas Blühm has pointed out, rare instances of polychromy in sculpture are deemed aberrations, as in the case of Donatello, or demoted to "the 'lower' category of decorative art," the typical classification of Della Robbia's ceramic reliefs.[3]

The rejection of color in sculpture stems from the Western predilection for purity. From Joachim Winckelmann (1717-1768) to Clement Greenberg (1909-1994), theorists have demanded that each art form be true to its essential nature, with the implication that color belongs to painting and is superfluous in sculpture. Gotthold Lessing's *Laocoön: An Essay on the Limits of Painting and Poetry* (1766), an early attempt to distinguish the arts (but which fails, in fact, to distinguish painting from sculpture),[4] was the inspiration for Greenberg's "Towards a Newer Laocoon" (1940). The latter essay is a modern manifesto of "purism" targeting the confusion of painting and sculpture.[5] Lessing's book was itself a reaction to Winckelmann's *History of Ancient Art* (1764), which, just as Greek and Roman works of art were being rapidly recovered, influentially decreed the superiority of uncolored marble sculpture. Believing that the best ancient sculptures were created without paint, Winckelmann advised his contemporaries, the Neo-Classicists, that "the essence of beauty consists, not in color, but in

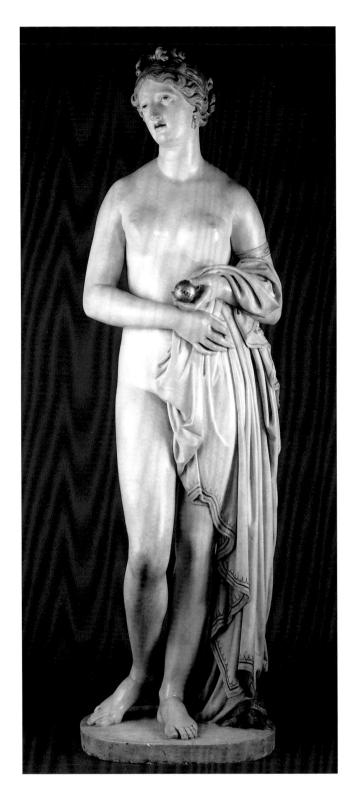

John Gibson
Tinted Venus, c. 1851-56
marble, painted, 175 cm.
The Board of Trustees of the
National Galleries and Museums on Merseyside,
Walker Art Gallery, Liverpool

shape, and on this enlightened point minds will at once agree. As white is the color which reflects the greatest number of rays of light, and consequently is the most easily perceived, a beautiful body will, accordingly, be the more beautiful the whiter it is."[6] Winckelmann's "'white' ideology," as Blühm describes it, retained its authority until the archeologist Antoine-Chrysostome Quatremère de Quincy supplied convincing proof of the existence of ancient polychrome sculptures in 1814.[7] Nearly half a century later, John Gibson's *Tinted Venus* (1851-56), whose nude body was tinted with a thin coat of rosy wax, heralded the nineteenth-century revival of polychromy when it was exhibited at the International Exhibition in London in 1862. The vogue for colored sculpture, only recently the subject of art historical investigations, extended from the ethnographic studies of Algerian models by Charles Cordier to the experimental wax figures of Degas and Medardo Rosso and culminated in the sculptures of Paul Gauguin and Picasso.

With the exception of its popularity with painters sidetracking into sculpture, polychromy was effectively banished from the twentieth-century sculptor's vocabulary. Truth to materials, the guiding principle of modern sculpture, demanded respect for the natural state of materials, which was not to be obscured by applied coloration. Another manifestation of aesthetic purism, truth to materials was initiated by Brancusi in conjunction with the carve-direct method of sculpture. "Every substance has its own characteristic," he is reported to have said. "A marble piece is not a bronze; a bronze is not wood. The point is, you don't ruin a material to coax it to speak the way we would like, you let it speak for itself and tell us things in its own language."[8] The concept was embraced by Henry Moore and Barbara Hepworth, but anathema to David Smith, who painted his metal sculptures from the very beginning. Developing his art from two dimensions into three, Smith progressed from painting to reliefs to freestanding sculpture in the 1930s. "My sculpture grew from painting," he wrote in 1960. "My analogy and reference is with color."[9] For Smith, color was a way of collapsing the distinctions between painting and sculpture, in a medium that "beats either one." When asked about the current state of polychrome sculpture (in 1964), he replied: "Now that's a dirty word, 'polychrome.' What's the difference between sculpture using color and painting using color?"[10] Smith depended on color to articulate an otherwise simple or homogeneous work of art or to unify the manifold elements of a complex one. His preference for bright colors on his iron or steel structures also resulted in the illusion of lightness and buoyancy. Smith's use of polychromy was nevertheless ill-received by purists like Greenberg, who was responsible for removing the paint from five works left in an unfinished state after Smith's death.[11]

Of all sculptors influenced by Smith, Anthony Caro was his most immediate heir. On his first visit to the United States from his native England in 1959, Caro was introduced to Smith and his work by Greenberg. Caro immediately abandoned his Moore-inspired figurative modeling for welded and painted steel. Like Smith, Caro used color formally: to unify, articulate, and lighten the perceptible heaviness of metal. His steel and I-beam sculptures of the 1960s, however, are more abstract, horizontal, and attenuated than Smith's. The playful quality of Caro's work influenced, in turn, his students at St. Martin's School of Art who created what was known as the New British Sculpture. Dramatically unlike Moore's naturalistic sculptures, painted three-

dimensional works by artists such as David Annesley, Phillip King, Tim Scott, and William Tucker utilized color as one of sculpture's primary components and "a principle area of innovation."[12] Essentially symmetrical, repetitive, or modular, the works of Caro's students were simpler in form and even more brightly colored than Caro's own, although they continued to take advantage of color's potential for, as Tim Scott said, "providing a skin envelope of a unifying character."[13] Scott's statement inadvertently highlights the distinction between applied and inherent color that would be so crucial to American sculptors of the same generation. "Found color," which characterizes British artist Tony Cragg's color-coded arrangements of plastic detritus, was a solution to the formal problem of color appearing to sit on top of a sculptural form as a skin rather than to be an integral quality of it. John Chamberlain's use of pre-painted auto body parts and Claes Oldenburg's use of colored vinyl achieved a comparable unity of form and color in the U.S. in the early sixties.

The 1960s was a decade that found the three dimensions of sculpture better suited to its materialistic world-view than the inherently illusionistic nature of painting. In the most insightful essay on the primacy of sculpture and the significance of polychromy, Lucy Lippard acknowledged that "it is only with the avant-garde's decreasing interest in painting that sculpture has come to the fore. This is a very literal period. Sculpture, existing in real space and physically autonomous is *realer* than painting."[14] The new sculpture, however, as she and the artists were quick to point out, did not evolve from the sculptural tradition, but from painting. Identified primarily as Minimalist, although Pop art and assemblage contributed to its proliferation, polychrome three-dimensional work in the 1960s was not modeled, carved, or

constructed (in the additive, relational manner of Smith and Caro) but conceived as singular, delimited objects, in which color, as Donald Judd observed, "is never unimportant as it usually is in sculpture."[15] Many years later, he summarized the historical position that he and his post-Abstract Expressionist colleagues found themselves in: "The achievement of Pollock and the others meant that the century's development of color could continue no further on a flat surface.... Color to continue had to occur in space."[16] Because of its use of space and scale, "the new work obviously resembles sculpture more than it does painting, but it is nearer to painting."[17] Like most artists of his time, Judd was trained as a painter and struggled with oil paint on canvas for more than a decade before progressing rapidly through a series of reliefs and painted three-dimensional objects. As a solution to what was known as the "skin problem," in the mid-sixties he began to have his work fabricated in such brightly colored materials as fluorescent Plexiglas and color-anodized aluminum. All of his subsequent work involves the precise articulation of space through planes of color. Judd's example and his crusade for the acceptance of color in sculpture are crucial to the developments of the 1990s.

Purism, then, saw its demise with Minimalism. With the breakdown of traditional artistic categories, "the arts themselves are at last sliding towards some kind of final, implosive, hugely desirable synthesis," Michael Fried sarcastically observed.[18] Fried's last ditch effort to salvage the uniqueness of painting and sculpture rested on the belief that "the concepts of quality and value—and to the extent that these are central to art, the concept of art itself—are meaningful, or wholly meaningful, only within the individual arts."[19] "Art and Objecthood," his infamous critique of Minimal art, is one more chapter in the debate begun by

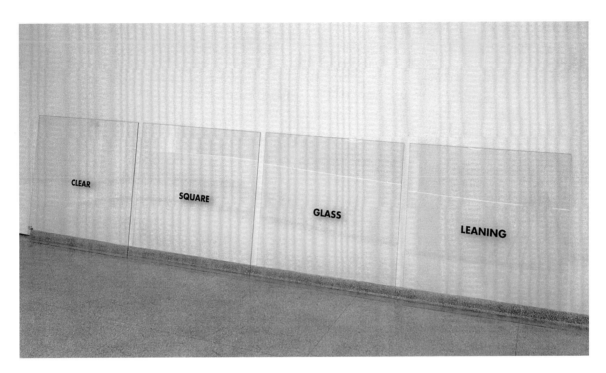

CLEAR

SQUARE

GLASS

LEANING

Joseph Kosuth
Clear Square Glass Leaning, 1965
glass plates with silk screened lettering, four plates,
each 60 inches square
Panza Collection, Extended Loan
The Solomon R. Guggenheim Museum, New York
© 1998 Joseph Kosuth/Artists Rights Society (ARS), New York

Winckelmann in the eighteenth century.

Although Fried's "Art and Objecthood" assimilated the diverse intentions of Judd, Tony Smith, and Robert Morris into one monolithic position, Morris was actually Fried's unwitting ally. Unlike Judd, Morris stressed that "the concerns of sculpture have been for some time not only distinct but hostile to those of painting."[20] By painting his Minimal works of the 1960s a neutral light gray, he believed he had eliminated the issue of color all together. Immaterial and sensual, color (along with highly finished industrial materials) could only result in what Morris disdainfully described as "candy box art."[21] As his own work developed from objects to installations of scattered materials, including thread waste, felt, and dirt, Morris participated in the rejection of Minimalism by

younger artists. Identified as Postminimalists, Eva Hesse, Richard Serra, Alan Saret, and others returned to the "natural beauty" of "uncolored" materials such as rubber, lead, and wire. Perhaps the most extreme example is Joseph Kosuth's *Clear Square Glass Leaning* (1965), which consists of four sheets of colorless plate glass, leaning against the wall, with black letters spelling out the words in the title. Intended to function as a work that defines itself, Kosuth's piece eschews not only the sensual but the visual in a pointed appeal to the mind over the body.

In the 1980s, a period dominated by photography, texts, and theory, the lack of interest in color initiated by the Postminimalists continued. Now identified as postmodern, this art amounted to what Dave Hickey called "a secular Reformation—a return of the Word at the expense of the flesh."[22] As so often has been the case throughout history, color was condemned explicitly as irrelevant and implicitly as immoral. In the Platonic tradition—to which we today are the heirs—of the association of color with the

immorality of pleasure for its own sake, according to Jacqueline Lichtenstein, "Moral puritanism and aesthetic austerity, along with resentment and an old, stubborn, and underhanded desire to equate drabness with beauty, thus make their righteous alliance and take delight in a constantly reiterated certainty: only what is insipid, colorless, and odorless may be said to be true, beautiful, and good."[23]

Aesthetics, traditionally concerned with issues such as color, was reevaluated, redefined, and even rejected as an appropriate field of inquiry for contemporary art in the 1980s. For Hal Foster, the "anti-aesthetic" was not only more critical than the modern aesthetic but hostile, even, to the subjectivity of taste and "the idea of a privileged aesthetic realm."[24] Craig Owens, on the other hand, attempted to realign aesthetics with a semiotic approach, which considers art as a system of signs. "And it is drawing," he claimed, "that imitates, signifies; color is only an addition." His readings of Alberti, Kant, Rousseau, and Derrida confirmed the "supplementarity" of color and its appeal to the senses rather than to the aesthetic judgement of taste. Based on Kant's association of beauty, discerned by such judgement, with morality, Owens (with Derrida) claimed for art an ultimately ethical nature, in which color has no role.[25] Like most postmodern artists and critics, Owens was nothing if not moral in his support of artists such as Hans Haacke or Barbara Kruger who favor the message over the medium; when it is used in their work, color reinforces the work's signification rather than delights the senses.

Aside from Owens's deconstructive method, there is nothing very unusual in his thesis, which is essentially an extension of the Renaissance debate between disegno and colore. The graphic, illusionistic potential of line over the additive nature of color had been championed by many since antiquity, but the discussion crystalized in the seventeenth century, when John Locke defined color as a secondary rather than primary quality of matter. It follows that form, as essential, universal rather than particular, and therefore colorless, is best engaged through drawing. Color is a mere sensation (what later artists will call a quality), although it has, as many writers admitted, the effect of enhancing realistic depiction. Colore is often associated with the body and disegno with the mind, a dichotomy that Jacqueline Lichtenstein recasts in terms of pleasure and reason.[26] The stereotypical identification of drawing as masculine and color as feminine, most notably by theorists such as Charles Blanc (1813-1882),[27] facilitates Lichtenstein's designation of painting, in its rhetorical use of color, as "the cosmetic art par excellence."[28] Ultimately traceable to the ancient distinction between Attic and Asian styles of rhetoric, in which the Attic is pure, unadorned, and austere and the Asian soft, ornamental, and decadent,[29] the disegno/colore debate is at the root of both modern purism and postmodern righteousness, and color loses out almost without exception.

Critics such as Greenberg and Owens are hampered by color's resistance to language.[30] Because it is not easily adaptable to words, it is often critically ignored or condemned by intellectuals while it is embraced, and has been throughout history, by non-academics. Color has been said to seduce the ignorant,[31] and, according to Charles Blanc, to appeal to "only barbarians, savages and the insane."[32] The elitism of this position is convincingly argued by Sal Torres later in this catalogue, so suffice it to say that the postmodern critic's claim to having wrenched art away from the academy and "official culture" has actually resulted in even more elitist forms.

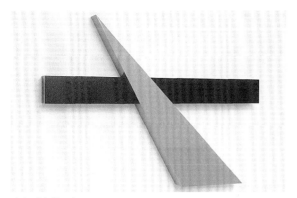

John McCracken
B-Thru, 1997
polyester, resin, fiberglass, and plywood,
69 x 96 1/4 x 7 inches

The situation is little changed from the Baroque, when the naturalistic polychromy of popular church sculpture appealed primarily to "those classes for whom art theory was not an everyday topic."[33] The tastefulness signaled by colorlessness is confirmed by the aristocratic penchant for black clothing, the origin of which John Gage dates to the Renaissance,[34] and which continues, especially in art world circles, even today.

Why then is color such a pressing concern for many contemporary sculptors? It is a way of getting in touch with the real and the real is for us manifested through the body. There are both religious and sexual dimensions to this argument. In the context of a discussion of the polychrome sculpture of Luis Jimenez, Dave Hickey observed that the luminous colors of oil paint were invented in the Renaissance "to paint the body of Christ as a physical being filled with light,... as a metaphor for the central tenet of Western Catholicism: that Christ was the word of God made flesh."[35] While, as a nineteenth-century commentator remarked, "It is pretty difficult to pray to a white Madonna,"[36] white was so traditional in sculptures of nude goddesses that viewers of Gibson's *Tinted Venus* found her unchaste.[37] It is not coincidental that the bold uses of color characterizing contemporary abstract

sculpture follow hard on explorations of the body by both painters and sculptors in the 1990s. Body art, deriving in part from a feminist perspective on the issues of postmodernism, extended the political critique while renouncing 1980s-style puritanism. Outside of that dialogue, works by artists such as Jeff Koons incidentally investigated polychromy and color's potential "to corrupt the purity" of sculpture. Comparing the glazed porcelain sculptures of Koons's Banality series (1988) to eighteenth-century Rococo figurines, Daniela Salvoni invokes an era dominated by feminine sensibility and devoted to pleasure and the seduction of the flesh.[38] François Boucher's paintings are perhaps the supreme example of the seductive potential of the depiction of flesh in color. In Rubens, this phenomenon elicits "a desire for touch," according to Lichtenstein, "as if painting were accessible to all the senses."[39]

The synthetic nature of perception is a standard assertion of phenomenologists. Rather than attributing the senses to individual organs and isolating their objects in perceptual experience, Maurice Merleau-Ponty proposed a more persuasive synthesis that occurs in the body. Color, he explained, is not seen with the eyes so much as it is bodily engaged. In a form of communion recalling the surrender to God by the participant in the Holy Sacrament, "I surrender a part of my body, or even my whole body, to this particular manner of vibrating and filling space known as red or blue." More than shape alone, an object's · form is comprehended by all the senses, and includes considerations of, for example, the tactile resilience of fabric, the tinkling sound of breaking glass, or the flexibility of a twig from which a bird has just flown.[40] Seeing a chrome door knob results in more than registering its silvery color and round shape; its cool temperature, smooth surface, and palm-size are equally apparent to the

percipient's body. Such synesthetic perception is at least partially satisfied by polychrome sculpture.

Sensible, beyond words and reason, the meaningfulness of color in contemporary sculpture is clearly beyond iconography. To say that an artist's use of pink signifies femininity or another's use of red connotes menstrual blood is superficial unless those qualities are *felt*. Merleau-Ponty advises: "We must therefore stop wondering how and why red signifies effort or violence, green restfulness and peace; we must rediscover how to live these colours as our body does, that is as peace or violence in concrete form."[41] The experiential nature of color is reinforced in the writings of Judd. "All experience is knowledge: subjective experience is knowledge; objective experience, which is science, is obviously knowledge. Color is knowledge."[42] As a way of being in the world, color is conceived of as a material instead of—against Locke—a quality. Judd claimed that color is "like material" and that it "is what art is made from,"[43] a sentiment echoed by John McCracken: "I make real, physical forms, but they're made out of color; which as a quality is at the outset abstract. I try to use color as if it were a material; I make a sculpture out of, say, 'red' or 'blue.'"[44] McCracken's works have often been described as solid chunks of color despite the fact that they are usually hollow plywood forms sealed in pigmented resin. Because he has considered color the primary concern of his sculpture for more than thirty years he is a fitting link between the Minimalists' generation and the younger artists included in *Chromaform*. Against McCracken's specificity, the widespread use of found color reflecting the proliferation of inexpensive, brightly colored objects of mass-production, discussed in the following catalogue entries, is most striking. Fashion and domesticity are also novel inspirations. Whether applied,

stained, cast, or found, color plays an essential role in all this work, which cares as much for the decorative and sexual as it does for the formal potential of color. The slinky tactility of crushed velvet, the fleshiness of rubber and wax, the skin-like tautness of vinyl and polyurethane film, and the icy slickness of Plexiglas and polished resin make this an exhibition of sensual indulgence. As unchaste as Gibson's *Tinted Venus* appeared to nineteenth-century observers, this may be, as Fried predicted, "some kind of final, implosive, hugely desirable synthesis."

Notes

1. Quoted in Lucy R. Lippard, "As Painting is to Sculpture: A Changing Ratio," in *American Sculpture of the Sixties,* by Maurice Tuchman (Los Angeles: Los Angeles County Museum of Art, 1967), 31.

2. Rosalind E. Krauss, *Terminal Iron Works: The Sculpture of David Smith* (Cambridge: MIT Press, 1971), 35.

3. Andreas Blühm, "In Living Colour," in *The Colour of Sculpture: 1840-1910* (Amsterdam: Van Gogh Museum, 1996), 14.

4. Edward Allen McCormick, "Translator's Introduction," in *Laocoön: An Essay on the Limits of Painting and Poetry,* by Gotthold Lessing (Baltimore: Johns Hopkins University Press, 1962), xxvii.

5. Clement Greenberg, *The Collected Essays and Criticism, Volume I, Perceptions and Judgements: 1939-1944,* ed. John O'Brien (Chicago: University of Chicago Press, 1986), 23-38.

6. Johann Joachim Winckelmann, *History of Ancient Art*, trans. G. Henry Lodge (New York: Frederick Ungar, 1968), 198. The racist overtones of this passage are made explicit in Winckelmann's subsequent remarks.

7. Blühm, "In Living Colour," 15-16.

8. Natalia Dumitresco and Alexandre Istrati, "Brancusi: 1876-1957," in *Brancusi*, by Pontus Hulten (New York: Abrams, 1987), 98.

9. David Smith, "Notes on My Work," *Arts* (February 1960): 44.

10. Thomas B. Hess, "The Secret Letter," reprinted in *David Smith*, ed. Garnett McCoy (New York: Praeger, 1973), 182.

11. As an executor of Smith's estate, Greenberg ordered primer removed from the works. See Rosalind Krauss, "Changing the Work of David Smith," *Art in America* (September-October 1974): 30-34; and Greenberg's replies, "Letters," *Art in America* (March-April 1978): 5; "Letters," *Art in America* (May-June 1978): 5.

12. Tim Scott, "Colour in Sculpture: Statements by Phillip King, Tim Scott, David Annesley and William Turnbull," *Studio International* (January 1969): 22.

13. Scott, "Colour in Sculpture," 22.

14. Lippard, "As Painting is to Sculpture: A Changing Ratio," 32.

15. Donald Judd, "Specific Objects," *Complete Writings: 1959-1975* (Halifax: Nova Scotia College of Art and Design, 1975), 183.

16. Donald Judd, "Some Aspects of Color in General and Red and Black in Particular," *Artforum* (Summer 1994): 113.

17. Judd, "Specific Objects," 183. Jessica Stockholder, one of the artists in *Chromaform,* described her own work in language nearly identical to Judd's: "Technically, it may be more related to sculpture than to painting, because it takes up space in the room, but conceptually it's closer to painting." Quoted in Raphael Rubinstein, "Shapes of Things to Come," *Art in America* (November 1995): 103.

18. Michael Fried, "Art and Objecthood," in *Minimal Art: A Critical Anthology,* ed. Gregory Battcock (New York: E.P. Dutton, 1968), 141.

19. Fried, "Art and Objecthood," 142.

20. Robert Morris, "Notes on Sculpture, Part 1," *Continuous Project Altered Daily: The Writings of Robert Morris* (Cambridge: MIT Press, 1993), 3-4.

21. Robert Morris, "Notes on Sculpture, Part 3," *Continuous Project Altered Daily,* 25.

22. Dave Hickey, *Air Guitar* (Los Angeles: Art issues. Press, 1997), 71.

23. Jacqueline Lichtenstein, *The Eloquence of Color: Rhetoric and Painting in the French Classical Age,* trans. Emily McVarish (Berkeley: University of California Press, 1993), 42.

24. Hal Foster, *The Anti-Aesthetic* (Seattle: Bay Press, 1983), xv.

25. Craig Owens, "Detachment: from the *parergon*," *Beyond Recognition* (Berkeley: University of California Press, 1992), 31-39.

26. Lichtenstein, *The Eloquence of Color*, 55.

27. "Here we recognize the power of color, and that its rôle is to tell us what agitates the heart, while drawing shows us what passes in the mind, a new proof of what we affirmed at the beginning of this work, that drawing is the masculine side of art, color the feminine." Charles Blanc, *The Grammar of Painting and Engraving*, trans. Kate Newell Doggett (New York: Hurd and Houghton, 1874), 146. Accordingly, "Color, then, is the peculiar characteristic of the lower forms of nature, while the drawing becomes the medium of expression, more and more dominant, the higher we rise in the scale of being." Blanc, *The Grammar of Painting and Engraving*, 5.

28. Lichtenstein, *The Eloquence of Color*, 43.

29. Lichtenstein, *The Eloquence of Color*, 92-93; John Gage, *Color and Culture: Practice and Meaning from Antiquity to Abstraction* (Boston: Little, Brown and Company, 1993), 15.

30. "Color is ... the irreducible component of representation that escapes the hegemony of language, the pure expressivity of a silent visibility that constitutes the image as such," writes Lichtenstein in *The Eloquence of Color*, 4.

31. See Lichtenstein, *The Eloquence of Color*, 153.

32. See Blühm, "In Living Colour," 34.

33. Blühm, "In Living Colour," 15.

34. Gage, *Color in Culture*, 155-56.

35. Hickey, *Air Guitar*, 69.

36. Alfred Lichtwark, quoted in Blühm, "In Living Colour," 40.

37. Andreas Blühm, "John Gibson," in *The Colour of Sculpture: 1840-1910*, 122.

38. Daniela Salvoni, "Jeff Koons's Poetics of Class," in *Jeff Koons* (San Francisco: San Francisco Museum of Modern Art, 1992), 22.

39. Lichtenstein, *The Eloquence of Color*, 167-68.

40. Maurice Merleau-Ponty, *Phenomenology of Perception*, trans. Colin Smith (London: Routledge & Kegan Paul, 1962), 212, 229-30.

41. Merleau-Ponty, *Phenomenology of Perception*, 211.

42. Judd, "Some Aspects of Color," 77.

43. Judd, "Some Aspects of Color," 113.

44. Quoted in Frances Colpitt, "Between Two Worlds," *Art in America* (April 1998): 88.

The Union of Color and Form
by Andréa Caillouet

Sculpture in the 1990s, as the artists in *Chromaform: Color in Sculpture* make evident, embraces the perceptual union of color and form. Addressing the formal, conceptual, and metaphorical functions of color in sculpture, the works in this exhibition reveal diverse results, limitless possibilities, and a shift toward a more interdisciplinary art.

Color is more traditionally linked to painting concerns since that is the realm where it has predominantly been employed. A new take on sculpture is possible when color can be considered one of its inherent issues. Is the color symbolic or expressionistic? Descriptive or illusionistic? Is the color naturalistic or is it representational, as in the works of George Stoll? Is it conceptual or is it decorative, as in the works of Caren Furbeyre? Is it applied or is it found, as in the works of Melanie Smith or Chris Finley? Does it designate or does it correspond to forms, as in the works of Daniel Wiener, or does it create new shapes as in the work of Jessica Stockholder? Michelangelo's belief that "color belongs to painting; it is a seductive sham" is no longer relevant. Artists John McCracken, Richard Rezac, Lillian Ball, and Polly Apfelbaum have thrust color into three dimensions in provocative new ways. However, the seductive nature of color still rings true, especially in the works of McCracken and Apfelbaum. McCracken's highly polished, glossy sculptures made with industrial materials have a sensual quality that calls to mind the materials' "real world" counterparts, such as automobiles and surf boards, while maintaining an inextricable link between form and color. Their highly reflective surfaces contribute to color illusions, qualities generally attributed to painting, which cause different angles of his works to seemingly disappear and reappear as the viewer moves around them.

Polly Apfelbaum's stained fabrics are luscious and fluid as though the color is still wet. The flow of the slinky cloths echoes the fluidity of paint. Apfelbaum pours liquid dye on cloth, "painting" in a traditional sense, However, by folding, draping, or piling the cloths, her works blur the boundaries between painting and sculpture. Through utilization of domestic materials, Apfelbaum makes metaphorical reference to the body, sexuality, and feminist issues. Her use of stain painting concurrently speaks of a tradition of stain painters (such as Helen Frankenthaler and Morris Louis) as well as to the implications of a "stain" as it relates to the body.

While Apfelbaum, Melanie Smith, and Hills Snyder are making works that speak of both painting and sculpture, Lillian Ball clearly is concerned with making three-dimensional objects. Ball's vividly colored sculptures of domestic and consumer objects are whole-heartedly humorous and as playful and inviting as a stack of caged bouncing balls waiting to be freed by a loose kid in K-Mart. Her use of color and materials is related to her subject matter—not in the sense that a dog house shaped like an igloo is literally red (although it might be) but that the red of the sculpture, *Dogloo* (1994), as well as its rubber material, is often found in the same consumer places and contexts where one might purchase a dogloo. Her use of color also emphasizes the accessible nature of the objects whose strangeness is compounded by the fact that, although they refer to functional objects and seem as though they could be functional themselves, upon further inspection they clearly are not. What was once negative becomes positive in that the sculptures are made from the spaces in and around everyday objects thus creating sculptures that are at once familiar and abstract.

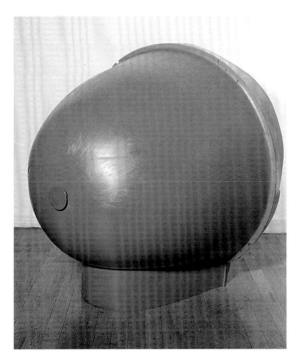

Lillian Ball,
Dogloo, 1994
flexible foam rubber and colorant,
39 x 37 x 32 inches

While Richard Rezac's palette is substantially different from Ball's, his subtle, understated colors initiate a similar playfulness and approachability—they seem friendly and inviting. The pastel colors of the heavy wooden pieces exude an illusionistic lightness and airiness that causes Rezac's untitled banister-like work (1992) to look as though it could not possibly catch you if you fell. The abstract shapes slowly reveal their complexity while their unpredictability is accentuated by the juxtaposition of asymmetrical and symmetrical parts.

Although it may be impossible to conceive of an object without color, never before have color and form been so united. Color has become indispensible to painters and sculptors alike. With the decline of the equation of colorlessness with sophistication, color has assumed a more prominant role in sculpture. It is no longer bound by categorization, and this liberation has made color one of the most charged issues of the nineties.

Hue du Jour

by Sal Torres

The sculptures in *Chromaform* may strike you as familiar even though you haven't seen these artworks before. They seem familiar because, in a sense, you probably have lived with them all of your life. While these artworks are mostly about form and color rather than representational imagery, it could be said that they are made from the substance and components of our image-cluttered culture. They are a creative take on everyday life, derived from our everyday visual experiences—culled from shopping malls and closets—and yet they also derive from art history itself.

In spirit, works such as these have been around since the Renaissance. Back then art established itself into two well-defined camps: high art, which concerned itself with intellectual and formal pursuits, and low art, whose concerns were primarily decorative. The works in *Chromaform* are the historical fruit of those two aesthetically diverse but formally similar branches of art. On the one hand these works are serious in their artistic intent, while on the other they display irreverent attitudes which seem to pose a threat to the seriousness of high art.

Indeed, the artists represented in *Chromaform* have transcended both the sometimes-too-strict bounds of high art and the too-easily accessible kitsch of everyday life.[1] With that transcendence their works comment on our own lives and on our thinking processes. They cause us to question our concepts of art and perhaps even our thoughts on past and present culture. We wonder where these works fit in relation to traditional sculptures, cast in bronze or chiseled from marble. And just as seriously, we might look for the relationship of these works to those non-art yet equally compelling bright plastic, metal, or glass objects in our consumer culture.

Typically, the "color-free" forms of artists such as Michelangelo, Maillol, and Richard Serra come to mind when we think of sculpture. Whether isolated in museums or situated in public spaces, the monumental works of those great object-makers are based on aesthetic and intellectual visions that can seem inaccessible to the average person, whose everyday existence, through the millennia, has been replete with colored forms. In the Renaissance, those were typified in polychromatic madonnas or other sundry religious icons of painted wood and plaster. Later, these everyday household items of everyman's art took the form of imitation Tiffany lamps, pink lawn flamingoes, and even the displays and decorations of Christmastime. And that separation of art and life, of form and color, of high from low, has remained essentially true in spite of Picasso, Warhol, and others, who introduced us to more pedestrian forms of sculpture, but who also remained tied to the world of high art, unable themselves to overcome the space between high art and everyman.

Chromaform, however, helps to realign what some might see as the elitist sensibilities of the past, which have taken the form, for example, of Serra's *Tilted Arc* or David Smith's *Cubis*—sculptures whose meaning is not clearly accessible. In *Chromaform* we find a synthesis of high and low art, a pluralistic union of interesting, entertaining, and thought-provoking, people-oriented art. *Chromaform* celebrates a commitment to color as well as a commitment to the democracy of vision in lyrical works such as Chris Finley's interactive piece, *Match Any Pair...* (1994)*,* and the socially-connected narrative installations of Melanie Smith. They are on one hand as openly friendly as Carlos Mollura's giant football-like inflated plastic forms, and as subtly intimidating as Thomas Glassford's vinyl constructions. From the thoughtful form exemplified in Richard Rezac's

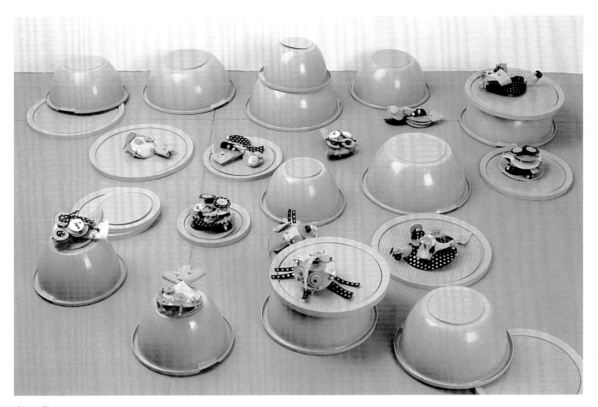

Chris Finley,
Match any pair..., 1994
mixed media, dimensions variable

Untitled (92-08) of 1992 to the sensual colors and fabrics in Polly Apfelbaum's *Champagne (Puddle)* (1993), we find a range of work from the contemplative to the celebratory.

Chromaform blurs the once seemingly sacrosanct boundary between "art" and "kitsch." The artists of *Chromaform* are making popular art which draws its energy from both the low and the high. They have taken sculpture a step beyond the recognizable, colorful objects of our everyday culture and strewn them confidently across the high ground of tradition-based art. *Chromaform* is a commitment to color in sculpture. These works bridge the once separate worlds of mind and eye.

Note

1. Kitsch is a form of popular art born of the industrial age when inexpensive, mass-produced objects and forms of entertainment began to satisfy the demands of a newly literate public. Kitsch is too easily accessible to be intellectually challenging and so readily consumable that it lacks the authenticity of well-crafted and historically-informed art. The definitive essay on the subject is Clement Greenberg's "Avant-Garde and Kitsch," initially published in *Partisan Review* (Fall 1939): 34-49.

Polly Apfelbaum
by August Di Stefano

One aspect of an artistic process may be the material. In the work of Polly Apfelbaum, the support and surface interest derive from working primarily with fabric and dye. Apfelbaum applies colored fabric dye to crushed stretch velvet in irregular, seemingly repetitious, or analogous shapes. The material is cut by hand and often hemmed just outside the blots' perimeter. Literally hundreds of these pieces have been produced for a single installation, as was the case with *Ice* (1998) and *Eclipse* (1996). Diverging from that is *Bouquet* (1992), in which a series of crushed stretch velvet sections, each with a stain, is folded, and presented as a stacked pile. Apfelbaum's work utilizes the interspersing and interchanging of quantity, color, form and scale of units, stains, articles, openings. And within a work, these material adjustments vary; that is, they are not rigid or exclusive. The recognition of control, and lack of, is expressed not only in the construction of these objects, but in their presentation. About her materials and their relationship with context she has written, "They flow, taking on the shape of the container, or whatever else is in close proximity."[1] Through an active participation and negotiation with the architecture of a space (and those elements related to it: walls, floor, columns, as well as the objects placed within it), the interest in context is established. Adjustments can be directed toward the repetitive, toward the incremental, or toward the substantial. What is important to her is "The everyday: the realm of repetition, reiteration and routine, that which does not declare itself a work of art, first of all."[2] Oscillating between the systematic and the reckless,[3] the exponential and the incremental, the concealed and the revealed, and that which employs the hand as well as references to mass-produced popular culture, her work enables the viewer to align

him- or herself with the multi-linguistic functions that it may offer: personal experience, association, the psychological, and the physiological. Valid descriptors of her work include: cellular structures and biological affinities (the "floating feet" of an amoeba, a paramecium, or bacteria coupled with a stain from a bodily fluid), the interior of a lucid and fragmented Monet water lilies painting, bodies of water, spectral droplets, undulating topographical surfaces that suggest not only a liquid aesthetic, but the liquidity of perception and association. The relevance of the latter is expressed in the artist's statement, "From Fold to Fold," in the magazine *New Observations*: "Fabric, for me is a liquid material."[4] Perception plays a crucial role, from the intent of the artist to the will of the viewer.

Quantity and slight variations in shape, scale, and color offer the viewer a specific and difficult visual language, much like a code that needs to be deciphered. Encoding is characteristic of a number of her pieces, but is a subject of *The Enigma Machine* (1994). Following WWI, the Germans devised a machine, the Enigma, for sending coded messages. For the Allies, the codes, when intercepted and solved, marked a turning point in WWII. Paired with this notion of encoding is Apfelbaum's deliberate application of colored dye and its integration with the ground (fabric dye staining crushed stretch velvet). The result may be central to the interpretation of this work, servicing the formal qualities and leading toward the metaphoric and the conceptual. In *Peggy Lee & the Dalmatians* (1992), for example, the application of black dye on white fabric denotes a recognizable pattern—velvet Dalmatian "skins" dispersed on the floor. With the aid of its title, the theme of vanity in popular culture is recognized, abstracted, and comments on itself. In Apfelbaum's realm, a dialogue between the formal and conceptual dimensions of a work is initiated, displacing neither. Repetition, reiteration, and variation are aspects of the visual, as well as the linguistic. The work may inform as much as it may be informed.

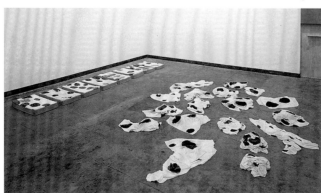

Polly Apfelbaum
Peggy Lee & The Dalmations (foreground), 1992
crushed stretch velvet and fabric dye, dimensions variable

Notes

1. Polly Apfelbaum, "From Fold to Fold" (artist's statement), *New Observations* (January-February 1996), 12.

2. Polly Apfelbaum, quoted in *Polly Apfelbaum at the San Francisco Art Institute* (San Francisco: San Francisco Art Institute, 1997), n.p.

3. Interview with the artist, 16 June 1998.

4. Polly Apfelbaum, "From Fold to Fold," 12.

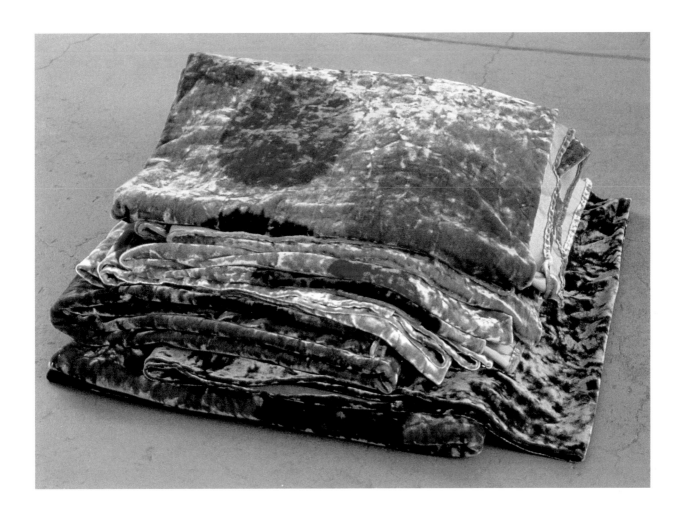

Polly Apfelbaum
Bouquet, 1992
crushed stretch velvet and fabric dye, 18 x 15 x 15 inches

Lillian Ball
by Patrick Yarrington

Lillian Ball has studied silver design in Mexico, history of ethnographic film at Harvard, architectural rendering at Parson's School of Design, ethnographic art at Columbia University, and anthropology at the New School for Social Research in New York City. She has received several fellowships and awards including an Individual Sculpture Grant from the National Endowment for the Arts and a National Heritage Trust Grant. Ball's works have been exhibited widely, not only in New York and Los Angeles, but also in France, Austria, and Germany. With this impressive and diverse background, she creates colorful sculptures informed by great wit and humor. Ball's interest in anthropology led her to work with what she considers modern cultural artifacts. By using objects which reflect our modern-day obsession with health and leisure, Ball seems to comment on our need for these things as well as our taking them for granted.

Ball's brightly colored sculptures are made out of foam rubber and platinum based silicone rubber which are used to cast the interiors of objects you might find in your home: bathroom sink basins (*Chromasomatic*, 1995), bathtubs (*Tenter le Diable*, or *Tempt the Devil*, 1995), shower floors (*Stall*, 1995), even a plastic igloo-shaped dog house (*Dogloo*, 1994). These objects necessarily employ negative space in their design and function. In Ball's versions they become solid and thick, the negative transformed into the positive. In her solo exhibition scheduled for the year 2000 at the Jersey City Museum, entitled *Backyard Monument, Jersey Pastoral*, she uses a similar conceptual theme. Objects such as a BBQ grill, an inflatable pool mattress, an electric bug-zapper, a pool slide, and the floor of a large backyard swimming pool make up this body of work.

Ball's work developed from the tradition in sculpture known as "truth to materials." Her influences include Eva Hesse and Richard Serra, two artists who worked in this vein. Ball's early work, in dark gray lead, was a response to lead's properties and potentials as well as an attempt to subvert the idea of truth to materials by folding the lead as if it were paper.

In her recent casts of colored rubber, Ball continues to work with malleable materials, only now color has assumed a significant role. The color in her work was, in fact, arrived at through the first few rubber pieces she made. The rubber was inherently a greenish-blue. The artist liked what she saw, which led to the intentional use of bright colors. Ball's color is neither applied nor arbitrary but specific and intentional. She often seems to indicate the sources of the work through color choices. For instance, the baby bath tubs (*Double Dub*, 1996-98) are dark blue, which suggests water. However, the forms are solid and opaque. Where a figure might inhabit the interior of an actual bathtub, these deny any access to the inside, visual or physical. In the process of casting, the rubber completely fills the chosen objects and is colored throughout. The foam or rubber is also colored as it's mixed, so the sculpture is thick with color and if we could cut it open, we'd find the interior is the same color as the exterior. This approach to color and sculpture is similar to John McCracken's claim that he actually makes his work out of color (as discussed elsewhere in this catalogue). Although their materials and processes differ, both McCracken and Ball conceive of and treat color as a material in itself.

The very thickness of Ball's sculpture elicits a physical and emotional response in us. It is a sense hard to describe and one necessarily of the body. It causes us to want to touch the work. More than that, to squish it. Added to this sheer formal and physical response is the recognition of the source object, the mold from which the work comes. Ball enjoys the subtle ambiguity of her work and invites us to "guess what it is." In fact, the vague quality in her sculpture is very important. She wants us to wonder about the object and try to figure out why it seems familiar. Indeed the sculptures are vaguely familiar, not in the sense of "I've seen this thing before," but more along the lines of, "this feels familiar in an unsettling way." The longer we investigate the piece, the further we are drawn in to not only figure out what this thing is but our connection to it. Even if we are not able to identify the object, we feel we should be able to. In the sense that you can "almost put your finger on it," or it's "right on the tip of your tongue," it references the body again.

Despite their attractive colors, Lillian Ball's works inhabit an ambiguous and playful gray area. The initial guessing at "what it is" and attraction to the fun shapes and bright colors gives way to a deeper understanding of ourselves and how we relate physically and emotionally to objects. Seemingly mundane household items normally taken for granted earn a new appreciation and deserve a second look. Ball's work, which is deceptively simple, also reminds us of our own physicality, including our needs, desires, and limits, urging us toward exceptional ways of perceiving our world.

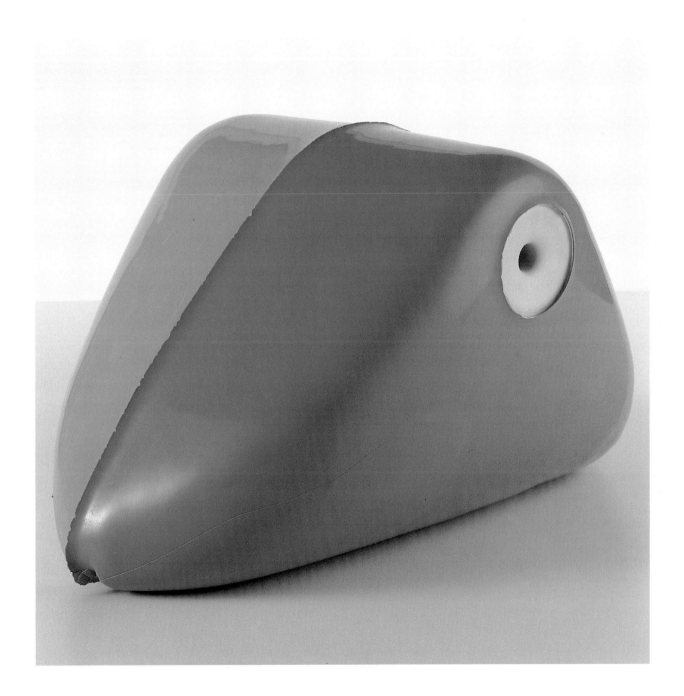

Lillian Ball
Chromasomatic, 1995
platinum based silicone rubber, 9 x 18 x 12 inches

Chris Finley
by David Jablonski

Certain words seem to pop up again and again when describing Chris Finley's sculpture. Words like odd, eccentric, quirky, and user-friendly describe his interactive assemblages of ready-made items. *Ganoid Ganache x3* (1994) includes a Tupperware tub, a place mat, shower curtain rings, a Tupperware lid, a dish rack, a plastic plate, a napkin ring, and a Tupperware container, among other things. Various items such as automobile floor mats, pencil stubs, melted crayons, six pack rings, milk crates, salt shakers, and flower pots have been used in other works. With the wide variety of materials, the bright pastel colors, odd juxtapositions, and the way they are meant to be viewed, the works come across as very idiosyncratic.

Finley's work is not meant to be appreciated with just the eyes. In a breach with the conventional notion that sculpture is not to be touched, these works are meant to be taken apart, looked at, spread out, and reconfigured.[1] As they are disassembled one runs across all kinds of bric-a-brac contained inside the larger elements. More and more information is playfully discovered as the various layers are removed. In fact, it is the file within a file organization on a computer that Finley has used as a model for sculptural form. The taking apart of the sculpture is meant to be like clicking and opening a window on a computer to get to the next level of information. After all is said and done, there is no set configuration, no right conclusion to be reached from the disassembly of one of Finley's pieces. What is important is that the viewer engages the sculpture and discovers the numerous bits of information to be found within. It's not so much that the viewer got there, but *how* he got there. Finley's work celebrates play, spontaneity, and unpredictability, although the pieces do have a sense of order to them. Objects that have no real relationship are put together in ways that make sense, but it also makes sense for them to come apart. The works are fun and quirky and express "a gentle resistance to convention and conditioning."[2]

Finley lives and works in Penngrove, California, and has exhibited in a number of solo and group shows both nationally and internationally. His most recent work includes a series of installations and paintings that continue the interactive and playful aspect that characterizes his work. Although this work is more complex and on a larger scale it still requires the active participation of the viewer for the work to be fully appreciated, like having to jump on a trampoline to catch a glimpse of a painting on an opposite wall. The viewer completes the work. "I want the viewer to feel important," Finley says, "so the work is more than me in a way."[3]

Notes

1. *Chromaform* includes two such works, but because they are on loan from collectors, a temporary ban on hands-on interaction is in place.

2. Carmine Iannaccone, "Chris Finley," *Art issues* (January-February 1995): 36

3. Hunter Drohojowska-Philip, "Finding Connections to Virtual Reality," *Los Angeles Times*, 12 January 1997, 67-68.

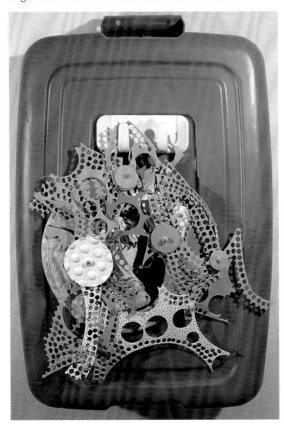

Chris Finley
Ganoid Ganache x 3 (detail, file open), 1994
mixed media, dimensions variable

Chris Finley
Ganoid Ganache x3, 1994
mixed media, dimensions variable

Caren Furbeyre
by Wendy Atwell

In the late 1960s, Robert Irwin, a seminal artist of the Light and Space movement in Los Angeles, produced a series of painted discs that were lit from above and below. Caren Furbeyre explains that they "perceptually seem to fade into their own shadows and ultimately into the wall upon which they hang."[1] These pieces raised issues which, years later, continued to be debated during Furbeyre's formative years. She received her B.F.A. in 1983 and M.F.A. in 1990 from the Art Center College of Design in Pasadena, California, and lived in Los Angeles until 1995, with a three year interval in New York. Her work is based on a combination of the two issues raised by the Light and Space movement— the "phenomenology of perception" and "how the object dematerializes into the environment"—and her interest in color as a system.

Furbeyre's sculpture presents color clearly and directly through the use of geometry and transparency. In fact, the pure and sensual presentation of color is the signature quality of her work. Furbeyre's clear rainbow colors forestall any inquiry into their potentially symbolic meaning by evoking a sensual, bodily response. According to Furbeyre, color is a language without words. Some of her work is reminiscent of brightly colored, potent chemicals in glass beakers. Playfully referencing the attempts of nineteenth-century science to classify colors into specific categories, many of her sculptures reveal the impossibility of drawing such lines by questioning where one color begins and another ends. Furbeyre repeatedly draws lines to establish linear divisions in her work (particularly in the work that incorporates liquids such as colored oil and water), only to reveal how color moves through them.

Because of her interest in color as a system, Furbeyre selects colors according to their function rather than using taste or intuition. Comparing color to mathematics, she explains: "Geometry is a mathematical language and like color is easily manipulated into systems and patterns." In *Chromatic Extrusions* (1998), Furbeyre systematizes colors that range from blue-green to blue-violet by breaking them down into tiny dots painted in a geometric grid onto Plexiglas. Her medium is always consistent with its function—hard and slick; clean and pure to enhance the gemlike quality of her work. As she has done in past work (e.g., *Stacked Primaries,* 1994), she paints the dots with glass paint, which is also transparent.

Furbeyre's latest work presents a new level of complexity. Although color, geometry, and transparency continue to be the main issues of her new work, Furbeyre has complicated the system. The media used in *Primary Star Shift I/II* (1998) channel color in a magical and enchanting way. This delicately constructed sculpture transforms the banal mirror hanger, the familiar plastic star, into a glowing, luxurious vehicle for color. Furbeyre's round "tabletops" are divided into tricolor pie-shapes consisting of two layers of stars set on screws; the screws balance in holes which Furbeyre drilled into the mirror in a geometric pattern. Each hole is painted inside with glass paint. Furbeyre then placed pieces of mylar cut in the same star pattern directly underneath the mirror hangers. The sculpture includes only primary colors. For example, one level contains red beneath and yellow above, but the mirror surface reflects the images of both layers, creating the secondary color, orange. The two "tabletops" in *Primary Star Shift I/II* differ because the two levels of colors are reversed: upper colors on one are the bottom colors on the other. While the shape of the mirror hangers resembles either a star or a flower, Furbeyre's work forgoes any organic references. "I stay away from the organic form," Furbeyre explains, "because it reads of the artist's presence. I am more interested in some sort of other presence. By this I mean not so much an otherworldly presence (although that may be possible) but rather the presence of a system which seems to have its own rules."

In reviews, Furbeyre's work is often described as beautiful, which raises the question of the definition of beauty. In Furbeyre's case, beauty is connected with the powerful manner in which color engages the senses. David Pagel's description of her work provides an anology of beauty's effect: "The shimmering surfaces of Furbeyre's three-dimensional diptych look as if they have captured hundreds of gallons of liquid light. To see this color-saturated work is to be drawn like a moth to a brightly burning lantern."[2] Like a synthetic drug designed to replicate a natural body chemical, these sculptures trigger the viewer's non-linguistic, instinctive attraction to color.

Notes

1. All quotes are taken from an interview with the artist, 23 April 1998.

2. David Pagel, "Art Reviews/Liquid Light: Caren Furbeyre at Mark Moore Gallery," *Los Angeles Times*, 16 January 1998, F28.

Caren Furbeyre
Primary Star Shift I/II (detail), 1998
acrylic, acetate, and metal, 30 x 34 x 30 inches

Thomas Glassford
by Mélida Buentello-Olivo

Thomas Glassford's work conveys an almost erotic sense of pleasure played off against the coldness of its subject. Preposterous inventions of a pseudo-industrial nature become sensuous compositions as a result of the juxtaposition of unexpected natural and artificial materials, which he brings together as if each could not exist without its opposite.

In the past, Glassford was primarily known for his works using actual gourds, which he manipulated with handmade metal hardware, but lately he has been using vinyl, neoprene, and leather along with other metallic elements. Throughout his diverse body of work, the violence of the mechanical world is imposed upon and overcomes the pure and pliant structures of the natural world. The natural materials he uses include not only gourds, but leather and wood, which signify the organic, while chrome-plated or stainless steel hardware conjures up the artifices of technology.

"I have always felt the need to directly engage … the body, address its scale, enthrone or enshroud, encased in materials fertile or sterile,"[1] he says as he envisions this human body in the silhouette of the gourd. Like a human torso, the helpless gourd is tormented by the sadistic manipulation of metal instruments, against which it is powerless. Moreover, the stretching and ripping of his materials, as if they were skin, imply the notion of punishment in restrained displays of passion.

Evolving from previous concerns, four of his recent works are included in Chromaform. Cyber-Gourd Suite (1994) is a video of digitally animated gourds. In this work, the gourd is now active and free from the reprimand of metal hinges or technological instruments. Instead, its own metallic surfaces transform it into a hybrid of nature and technology. In five short sequences,

it moves through a series of organic and erotic performances. As the artist states: "There is always the attempt to extend the life, remove the frailty, restretch the skin and prove uncorruptible in stainless glory to the delicate patina of time."[2] Related to the video is a recent cast resin sculpture from Glassford's ongoing Autogol series. Titled after a soccer goal made mistakenly against one's own team, the plump, gourd-like Autogol twists itself to insert its neck into its base.

Snake in the Grass (1997) is composed of lengths of black and white patterned vinyl, which replaces the natural leather of his earlier work. Zipped and strapped together, they form an immense plastic landscape. Tutti and Frutti (1997) is a pair of wooden boxes that are painted with lime green and lavender lacquer, pierced with orifices, and covered with glass held together by metal hinges. Beautifully crafted, Glassford's perfectly cold and rational works are always characterized by an "impeccable appearance" while, at the same time, they provide unfailing sensuality and pleasure.

Despite their susceptibility to a fantastic, masochistic interpretation based on the use of zippers, belts, and hardware, his works develop the idea of human cycles. They suggest the phenomenon of oscillation, of whatever goes around, comes around. An obsessive circling of turmoil, suffering, and pleasure flows disturbingly within ourselves, yet these cycles are basic to our nature as human beings. One of the purposes behind the creation of technology is to clean and purify the biological facts of everyday life. Its pleasurable cleanliness sterilizes turmoil and the unseemly. Yet our own creation, by suppressing our disturbed nature, is punishing us in a perverse way.

Glassford's education and his immersion in different cultures may have influenced his creativity as well as his idiosyncratic sense of humor. He was born in 1963, in Laredo, Texas, on the U.S.-Mexico border and received his education at the University of Texas at Austin, obtaining a Bachelor of Fine Arts degree in 1987. Growing up in south Texas, he was exposed to Mexican traditions, which continue to inform the work he produces in and around his studio in Mexico City.

Thomas Glassford
Latex (Cyber-Gourd), 1994
computer animation

Notes
1. Thomas Glassford, from the Autogol project at Curare, Espacio Critico Para Las Artes, 20 November 1990.

2. Glassford, Autogol project. The Autogol project is documented in a book edited by Carlos Ashida and Patrick Charpenel in a collection of essays from México Travesias.

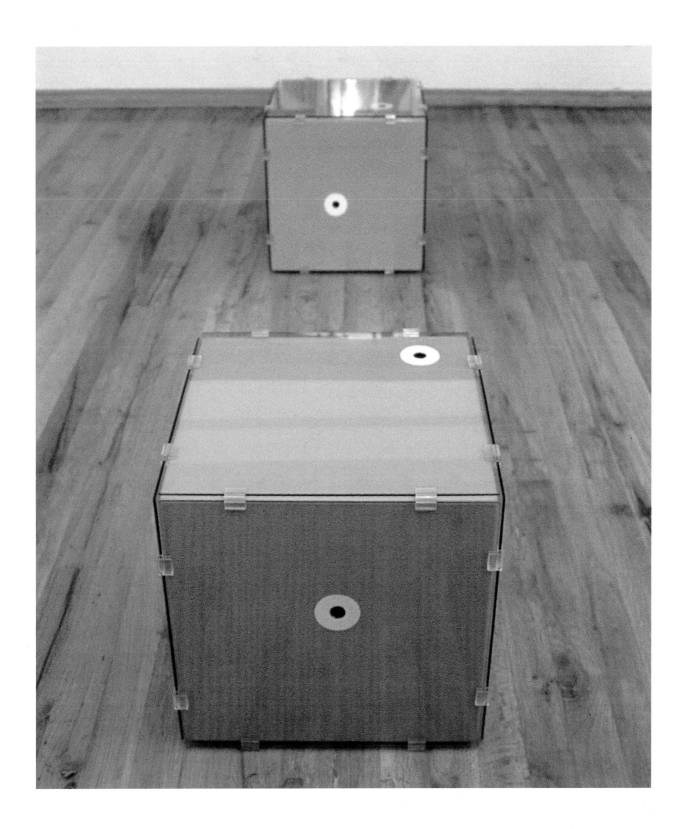

Thomas Glassford
Tutti and Frutti, 1997
glass and lacquer over wood, 2 units 22 x 22 x 22 inches each

John McCracken
by C. Cody Barteet

John McCracken's planks, pieces, or "things," as he commonly calls them, have been admired since he first created them in rich hues of red and blue in 1966.[1] Throughout the decade of the sixties, McCracken was included in almost all of the major sculptural exhibitions, such as *Primary Structures* (1966) and *Art of the Real* (1969). During the seventies and early eighties, McCracken received little critical attention, but in the mid-eighties, a renewed interest in his work led to retrospective and group exhibitions such as *Heroic Stance: The Sculpture of John McCracken, 1965-1986* (1986) and *One of a Kind: Contemporary Serial Imagery* (1988). From this McCracken has received international recognition at prestigious venues such as Galerie Nordenhake, Sweden (1991) and Kunsthalle Basel, Switzerland (1995).

While his palette has changed throughout the last thirty-two years, many other aspects of his work have remained consistent. Color is an inherent quality of his work, and although it is literally applied to his shapes, he conceives of them as solid forms of color. In creating the works, McCracken does not consider color as additive; it is an inherent quality of his work. It is not merely applied; it is a necessary means of creation. Because of the simplicity of the planks and other forms, such as columns and blocks, McCracken had been identified with Minimalism, a category with which he does not mind being affiliated, as he said, "because much of the work was about minimalizing and reducing and boiling down."[2]

The process by which he conceives his work is long and meticulous and begins by thinking his ideas through in sketchbooks, or by computerized drafting. Once the form has been conceived it is then cut out of plywood, built into the desired shape, and enveloped in fiberglass. Upon this McCracken pours a thick pigmented resin which is allowed to pool out slowly over the flat surface. After the resin has dried, he begins the slow and tedious process of sanding and polishing the pieces until they possess a slick mirror-like finish.

The most intriguing factor of McCracken's planks has to be the duality of physical and mystical dimensions that they create. He is able to achieve this duality by presenting the viewer with one of the simplest forms possible, which in it self establishes a complex relationship to its environment. His leaning planks require the support of not only the floor but also the wall. Retaining their physicality, the planks do not meet flush with either the floor or the wall. Instead, with their square cut foot and top they partake of the space they inhabit.[3] The planks maintain a physical presence in the space on a larger-than-life scale. However, the planks and other geometric forms do not overwhelm the viewer rather, they invite the viewer to meditate on their mystical qualities. McCracken achieves this by conceiving of his works as

> heroes or heroines that could say things or be things that might be useful in the terms of human development. It seems to me that a sculpture can have a stance that can indicate that it knows of, say, a great future, rather than knowing of only a negative future, or only knowing of a continuation of what already exists. To me work can really go past that and get creative about what humans can be.[4]

This is what McCracken wants us to get from his work: that we as human beings have not yet even begun to comprehend the powers of our own minds, as well as the complexity of our existence. Much of this derives from his own spirituality. Over the past decade or so, McCracken has made his belief in UFOs known, which can help us to better understand his work. The artist has stated that "I often think in metaphorical terms of making sculpture that appears to have been left there by a UFO, by beings from another and more developed dimension, world or phase in time."[5] This is substantiated by the meditative qualities of his work, which produce the feeling of being a part of something much greater than our own existence. The universal or cosmic dimensions of his work suggest that McCracken wants us to realize the endless possibilities of our own minds while meditatively gazing at his pieces. John McCracken does not ask us to believe in UFOs. Instead, he invites us to go on a never-ending meditative and spiritual journey in our own minds, much like the one he enjoys when creating his own work.

Notes

1. Thomas Kellein, *McCracken* (Basel: Schawabe & Co. AG, 1995), 10.

2. Quoted in Frances Colpitt, "Between Two Worlds," *Art in America* (April 1998): 87.

3. Stephen Westfall, "John McCracken at P.S. 1," *Art in America* (April 1987): 214.

4. Quoted in Edward Leffingwell, *Heroic Stance: The Sculpture of John McCracken* (Long Island City: P.S.1, 1987), 9-10.

5. Patricia Bickers, "UFO Technology: Interview with John McCracken," *Art Monthly* (March 1997): 4.

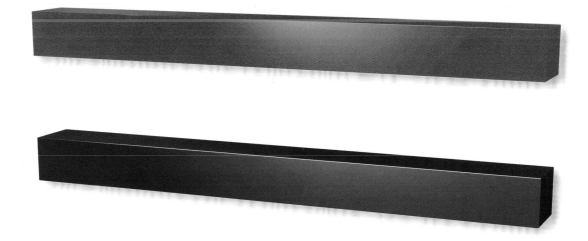

John McCracken
Red - Blue, 1998
polyester resin, fiberglass, and plywood, 2 elements 31 x 96 x 10 overall

Carlos Mollura
by Bethany Springer

Carlos Mollura infuses structures of polyvinyl-chloride film and polyurethane film with compressed air, generating taut, monumental yet delicate forms vulnerable to the slightest puncture. The resulting forms range from spheres to bars and square segments to human-size "pillows" and, most recently, to torpedo-shaped capsules. By constructing the shapes in both clear and opaque industrial vinyl and polyester sheeting, Mollura erases the line between interior and exterior, blurring positive and negative space into an ambiguous union. The structures originate as flat two-dimensional panels of film which are cut to a particular shape and industrially fused to one another piece by piece until a complete form is enclosed. With the introduction of air into the series of flat planes, a third dimension is summoned. By extending and curving color in lucent and reflective planes, the artist virtually paints in space.

Reminiscent of Minimalism's precise configurations and educing images of the heroic sculptures of the 1970s, by artists such as Donald Judd or Richard Serra, Mollura's massive yet essentially weightless structures minify the viewer. Their voluptuous surfaces are instantly attractive yet the hovering forms seem to linger in mid-air, almost intimidating in their suspension of movement.

Pressurized until stretched taut, the forms conjure notions of empty versus full and the maximum capacity of each construction. Once inflated, the works themselves are full of absolutely nothing, as empty as the space encompassing their exteriors. The air inside the poly film seems synonymous with the surrounding air, except that a remarkable transition separates the two atmospheres. The inner air is visible but removed and intangible in a void that ironically registers "no vacancy." The space contained within the forms is a powerful presence and is as positive as the skin that encloses it. Although visibly similar, the air enclosed within the structure is extremely pressurized, so pressurized that the viewer could not imagine existing within the construction. Accessible to vision alone, the interior air is super-charged and enigmatic in its confinement.

Although whimsical at first glance, Mollura's untitled works approach a deep, hallucinogenic level that can be understood in terms of the sublime. What is unspeakable, what seems uncontainable, is in actuality contained within the capacity of the polyvinyl and polyurethane skins. Air, an immaterial force, is not only the three-dimensional element in the artist's work, but also the sublime factor activating negative space, the space between and around the poly film surfaces.

With their reflective and transparent surfaces, Mollura's forms respond to light and produce an eclipse in which the resulting shadows shift in fantastic patterns. The colored segments of his material also react to illumination, reflecting and emitting light of concentrated hues. Dealing with one or two solid registers within a single piece, Mollura utilizes color sparingly. Black, white, light blue, red, yellow, and orange appear in isolated incidents and usually in conjunction with reflective or invisible surfaces. For example, Mollura's untitled torpedo-shaped piece of 1998 contains a plane of solid light blue, which is supported by invisible surfaces and appears to diffuse over the breadth of the form, as if producing its own energy.

In his concern with light and space, Mollura mirrors those artists involved in the Los Angeles Light and Space movement of the 1960s and 1970s. By 1979, at approximately the time Mollura was commencing his undergraduate studies at the University of Southern California, Los Angeles was well-known for a style of art dealing with illusion and the sensations of light or space as palpable substances. Work from the late 1960s and early 1970s, including John McCracken's resin-coated sculptures, Craig Kauffman's vacuum-formed Plexiglas reliefs, Robert Irwin's disk and dot paintings, and Larry Bell's glass boxes placed a major emphasis on perception, specifically on the perception of emptiness, a vital component in Mollura's work. Addressing substance and the illusion of substance, interior and exterior, perception and awareness, Mollura examines consciousness and questions our process of seeing.

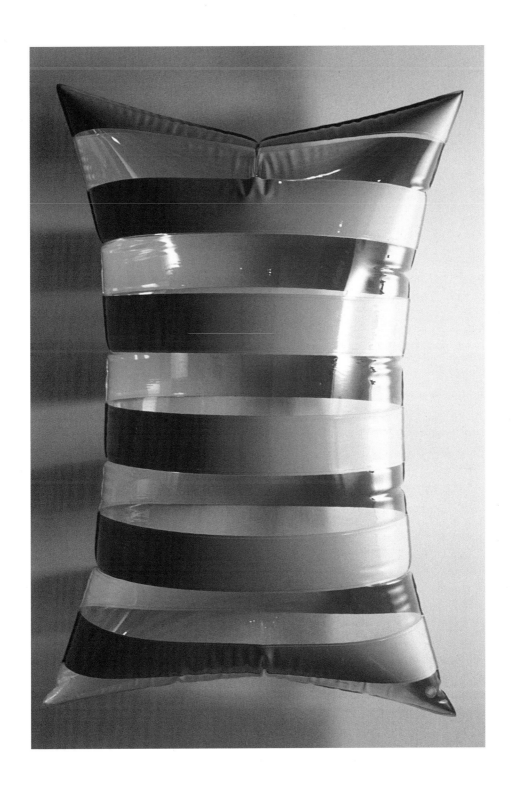

Carlos Mollura
Untitled, 1998
polyurethane film, 70 x 45 x 30 inches

Richard Rezac
by Kate Terrell

Spare and free of decorative effects, Richard Rezac's work may at first seem related to Minimalist sculpture of the 1960s. However, the objective and non-illusionistic qualities of Minimalism are replaced in this Chicago artist's works by elusive reference. They remind us of familiar, utilitarian forms of architecture or furniture but remain enigmatic. As they are subtly colored, his elegant objects possess a considerable lightness, while radiating power and significance through assertive shapes and distinction of form. Rezac's works appear effortless because the forms are controlled and simple, yet they remain contemplative and less austere than most Minimalist work.

Rezac's sculptures and wall pieces vacillate between the perfectly symmetrical and organic or lopsided; their colors appear to be part of their forms rather than artificially applied. He achieves the illusion of inherent color not by accident but through meticulous and deliberate effort, involving full-scale models and experimentation with color choices. By choosing lighter shades, Rezac achieves a wider gradation of shadows within a given work. For example, his pink and green

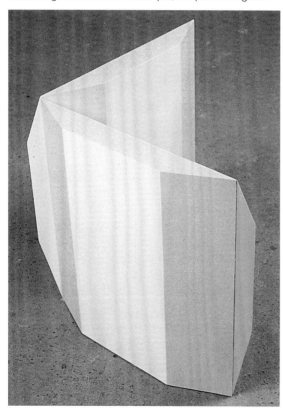

Richard Rezac
Untitled (93-01), 1993
painted wood,
20 x 22 1/2 x 30 1/2 inches

piece [*Untitled (93-01)*, 1993], included in *Chromaform*, takes advantage of the operation of light through color and unpredictable angles. Shadows transform the colors of one single form into differently appearing tones. The pink can appear red from one point of view and the green and the pink can look like the same color from another viewpoint. Because the degrees and transitions of shadows complicate perception and contribute to harmonious relationships of the elements within the sculpture, light and color play an integral role in Rezac's work.

Unlike the remote and spartan aesthetic of Minimalism, the line quality of Rezac's work is graceful and melodic. This animates even the simplest object with a distinct personality. A slight shift of a symmetrical axis or an unexpected lopsided curve is revealed through an intimate encounter with the work. For example, *Untitled (92-08)* of 1992, which resembles a yellow banister, is a construction of straight lines and other elements that appear to be perpendicular to the floor. Upon further inspection, one discovers that the entire piece angles slightly. Rezac's work creates tension by inviting a search for such inconsistencies.

Subtle juxtapositions and colorful illusions compel the viewer to be aware of his or her relationship to the piece. A slight change in position can alter one's perception of the work's shape or color. Whether the sculpture has the physical presence of a piece of furniture like the yellow banister or the delicate intimacy of *Sun and Moon* (1996), scale enhances the viewer's relationship to the work.

The construction of Rezac's sculpture varies from piece to piece. The joints and fitting of parts in his wooden sculptures are clean and precise, deftly mitered and secured. He employs traditional woodworking techniques that have been used for many centuries in furniture-making. With architectural integrity, the works are balanced and sound. Through this sophisticated construction, Rezac's works sometimes incorporate a sense of humor different from that of the well-known Chicago Imagists whose comic playfulness is consistently obvious. Rezac diffuses the aloof irregularities of form with an "uncertain sense of humor."[1] Witness, in his *Untitled (92-08)*, the subtle imbalance between the ethereal quality of the undulating top and the rigid base. Such nuances abound in Rezac's quiet constructions.

Note
1. Interview with the artist, 1 May 1998.

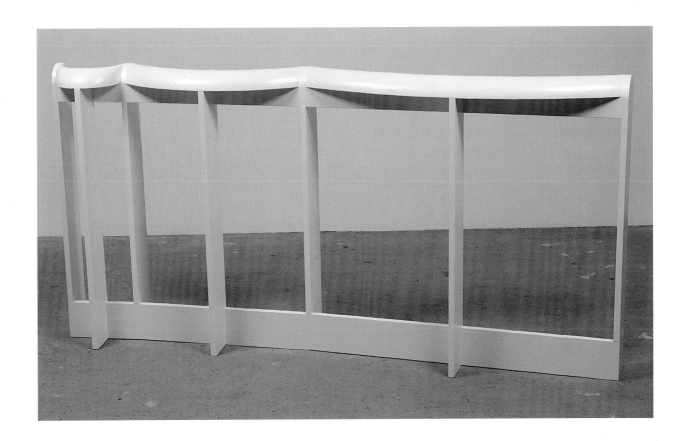

Richard Rezac
Untitled (92-08), 1992
painted wood, 35 1/4 x 71 1/2 x 11 1/2 inches

Melanie Smith
by Lisa Mellinger

Melanie Smith combines mass-produced objects that signify consumerism in installations of expressive yet restrained urgency. Her work consists of orange plastic objects created by our modern industrial world such as balloons, balls, and blow-up toys displayed, in the case of *Orange Lush VII*, on a sheet of fluorescent orange acrylic hung from the wall. After undergoing the evolutionary process of assemblage the individual components are practically unrecognizable and form a wall of pure color. Smith has lived in Mexico City since 1989, and is inspired by the raucous commerce of the streets. When she first arrived from her native coastal town of Dorset, England, with a group of English artists, they were offered space in an old typewriter warehouse and put together a group show. They sold their work and decided to stay in Mexico. She has shown in Mexico, California, Colorado, and South Africa. According to Smith, Mexico City is like Hong Kong or New York City because of the busy streets and displays of diverse merchandise, especially the utilitarian items in brilliant colors of plastic.

Melanie Smith
Orange Lush I, 1994
mixed media, 94 x 48 inches

In Smith's view, the material of plastic is responsible for the homogenization of merchandise. She has observed that Mexican artisans, who used to make traditional crafts by hand with natural fibers, are now mass-producing them from plastic in factories. New plastic technology has enabled designers to transform colorful products into mass-marketed objects of desire. Commerically, the visual aspect of color is used as a means of seduction in familiar examples such as a wastepaper basket in a dreamy translucent aqua blue or a bucket in sea foam green. For Smith, the various shades of orange plastic are particularly appealing. The objects she uses are chosen because of the color, not because of what they represent. Smith never paints or manipulates the objects. For instance, in *Orange Lush VII* tubes of orange plastic, netting, and starfish drape off the wall to produce a colorful synthetic beauty.

Melanie Smith's work can be compared to the work of sculptor Tony Cragg. Both artists use the wall, as well as plastic objects organized by color. However, while Cragg's plastic objects are often broken and covered in dirt, Melanie Smith's sculptures are made of new and store bought plastic items humorously juxtaposed. Perhaps an even closer comparison can be made with Chris Finley, who is also included in *Chromaform*, and uses newly purchased plastic items to create his pieces. Ordinary plastic bowls in different hues complement each other as they are playfully stacked to entice the viewer to rearrange them.

The urgency of Smith's work is expressed through the commitment to placement without sacrificing individuality. Like city dwellers living in a high rise apartment, these objects are clustered together creating an orderly uniqueness within an overall sameness. The artifacts collected are blended, not hidden, into a textured surface unity. The viewer recognizes the familiar items as modern objects of consumption made convenient and disposable. *Orange Lush VII* and *Instant Atmosphere Ultramix II* are synthetic guides for a fast paced society that neglects to notice its environment. Smith's work fully contributes to the new rebelliously humorous exploitation of colorful materials seen in *Chromaform: Color in Sculpture*.

Melanie Smith
Orange Lush II, 1997
mixed media and acrylic, 51 x 59 x 7 3/4 inches

Hills Snyder
by Susan Budge

Deciphering the work of Hills Snyder is like putting together the pieces of a puzzle in order to solve a riddle. Somewhere out of sight is the Joker, grinning mischievously as we attempt to unravel the work's symbolism and wry humor, which result from his observations of our culture and existence.

Snyder was born in Lubbock, Texas, and lives in Helotes, near San Antonio. His art work developed in the 1970s out of a form of narrative similar to lyrics from country love songs, seemingly serious, absurdly comical, or quietly cynical.

Snyder's objects and wall reliefs are constructed from birch plywood and Plexiglas. Formally, these industrial materials convey his interests in issues of opacity, reflectivity, surface quality, and color. Plexiglas simultaneously functions as a barrier and as a mirror. Relating to Snyder's obsession with signs, especially those that entice consumption, the rich colors and slick surfaces of this material are pleasing to look at, take in, and consume. Thus he draws the viewer into his realm.

In conjunction with their titles, Snyder's common forms can take on a mysterious quality. In *Red Rider* (1997), a huge smiley face gains a sinister quality when it is fiery orange. Its title, however, makes the piece amusing, as if the setting sun is smiling "goodnight." The inspiration for *Howl* (1998) was a French horn, yet the title makes us look for a beast in this abstract form. Both verbal and visual references engage the viewer in a silent dialogue of investigation, or a visual riddle, which may or may not be solvable. It is not important that viewers "properly" interpret Snyder's works, but rather that they engage with them. Through interaction with the work the viewer transcends the craziness of the "real" world and enters into Snyder's imaginary realm.

Snyder's four part piece in *Chromaform* creates just such a realm. Each part has an independent title, and together they create *The Secret Life of Ants* (1998), derived from the title of the book, *The Secret Life of Plants*. One component, *Jes Grew*, is a neon pink Plexiglas mushroom floating on a blue reflective square next to a yellow reflective square. Its position in a corner creates a reflection of another mushroom on a green square. The mushroom has long had an association with elves, fairies, and other magical creatures and potions. That association was further substantiated in the 1960s with the drug culture and the use of "magic mushrooms." This substance allegedly allowed some of its users a clearer vision into an otherwise unavailable realm, or state of being. *Diva*, a blue Plexiglas swim mask and snorkel, is mounted upside down on the wall near the floor. In contrast to our typically vertical posture on land, when diving we go upside down to reach and see the life below. The mask is used for diving, yet the piece is titled *Diva*, which refers to an opera star. The swim mask that was the model for *Diva* belongs to a prominent writer. Perhaps the title *Diva* relates to this writer, who dives into the art work she writes about in order to really see it.

The common thread between *Diva* and *Jes Grew* has to do with sources of uncommon vision. The central piece, *Ambassador*, uses the universal symbol of the ladder, thoroughly defined by J. C. Cooper:

> Ladder: The passage from one plane to another or from one mode of being to another; the breakthrough to a new ontological level; communication between heaven and earth with a two-way traffic of the ascent of man and the descent of the divinity, hence the ladder is a world axis symbol which, in turn, connects it with the Cosmic Tree and the pillar.[1]

Symbolizing transition and movement to a higher plane or another realm, Snyder leans his ladder over a framed piece of yellow Plexiglas, a window into another dimension. The blue Plexiglas of the ladder appears green in the yelllow reflection. It is interesting to associate the ladder with the dictionary's definition of an ambassador as "a diplomatic official of the highest rank appointed as representative in residence by one government to another." Could *Ambassador* represent an unseen Power, an uncommon vision, a cosmic "Diplomatic Official," someone to show us a new way of seeing? The answer seems to be given in the fourth element of the ensemble, a small flying saucer, hovering near the ceiling. The title of this piece is *One Eye, One Horn, One Leg*. Two thirds of this title is taken from Sheb Wooley's 1950s song entitled, *Flying Purple People Eater*. The third part of the title comes from the artist's readings in ethno-botany.[2]

Snyder gives us a lot of information to decipher; enough that the meaning will remain a mystery, something we can never be sure of. The "Joker" will not explain the riddle, he will just grin mischievously as we attempt to solve it.

Notes

1. J. C. Cooper, *An Illustrated Encyclopedia of Traditional Symbols* (London: Thames & Hudson, 1978), 94-95.

2. Interview with the artist, 1 April 1998.

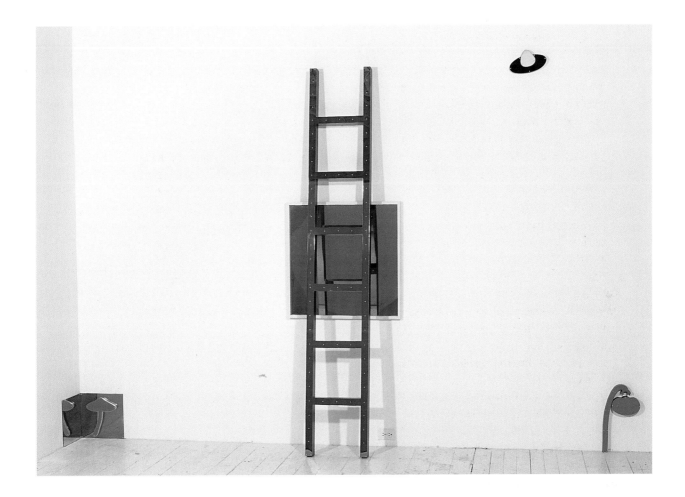

Hills Snyder
The Secret Life of Ants (Jes Grew; Ambassador; One Eye, One Horn, One Leg; Diva), 1998
acrylic sheet, birch, and enamel, 97 x 158 x 14 inches overall

Jessica Stockholder
by Ann Wood

Jessica Stockholder began making art as a painter. Although her work has since developed into installations or smaller scale sculptures, painting is still a main concern. In her smaller works, such as *Shoulder Length* (1995)*,* the relationship to painting can be seen in the piece's use of color and its interaction with the wall. By placing the work in close proximity to the wall and in many cases, attaching the piece to the wall itself, Stockholder is referencing the traditional site of painting, as well as suggesting that the viewer consider not only the works' more obvious sculptural concerns, but painting issues as well.

As three-dimensional painting, Stockholder's work is essentially formal. The haphazard and seemingly arbitrary way that she uses materials such as plastic crates, yarn, plastic fruit, and other commonplace items, asks the viewer to disregard the material's intrinsic meanings and simply consider color, composition, line, and form. For Stockholder, paint is simply another material of no greater or lesser importance than the found objects she employs. The application of paint to areas of her work is not a secondary concern, but rather an integral component of her work's formation. By using paint in this manner, Stockholder manages to consolidate the somewhat entropic composition that is her trademark into a beautiful, tactile display of color.

Examining Stockholder's oeuvre in *only* a formal, painterly sense, however, undermines her artistic achievements and ignores some of the elements that make her work so compelling. First there is the notion of domesticity, or the "female nest," that is made apparent by the stacking of plastic fruits, as well as the draping of yarns, and use of kitchen gadgets and containers. Second, by using plastic—brightly colored but none the less banal—items from mass culture, Stockholder draws our attention to mass production and the "plastic-ness" of our times. However, unlike some artists dealing with similar issues, Stockholder's work seems to be celebrating our K-Mart culture. In lieu of the critique so often seen in the work of her contemporaries, Stockholder chooses to use brightly colored found objects, paint, and space itself in such a way so as to create a piece with no pessimistic or negative overtones.

By making a sculpture that reads as a painting out of kitsch and found items, Stockholder is commenting on and at the same time motivated by postmodern concerns. Relying on postmoderism's tendency to deflate traditional categories and classifications, Stockholder's multidimensional art is just that—art. It is not required to be *only* a painting or *only* a sculpture or *only* art, or *only* kitsch. It can simultaneously be all of these.

Stockholder references art history as well. Her use of color as a motivating factor brings Impressionists such as Claude Monet to mind. Also, through her use of fruits and color, Stockholder seems to be creating a nineties Cézanne-like still life. And Robert Rauschenberg can not be overlooked as an influence, for Stockholder is definitely creating a type of nineties combine-painting. Dada is important, too, especially when one considers Stockholder's unexpected juxtapositions of materials in conjunction with the titles she chooses.

All of these issues are apparent in *Shoulder Length* and the work without a title from 1994. *Shoulder Length* is bolted to the wall, firmly anchoring its position as a painting, yet creating tension as it is clearly a three-dimensional sculpture. It relies upon the traditional theory of complementary colors by pairing yellow fruits with purple crates, and red yarn with a square of green. Form is achieved through the use of found objects that are transformed by their relationship with the rest of the piece into one solid composition. The Dada-like title evokes an offhanded and unrelated thought of the artist. At the same time, however, the title makes perfect sense in that it emphasizes the female, almost erotic nature of the red hair-like yarn draped down over the crates from wire mesh.

In the 1994 piece, formal concerns are again addressed through Stockholder's use of color and paint as a unifying compositional element. Concrete is combined with a found beach umbrella and draped yarn to reference everyday life, as well as art historical prototypes such as Georges Seurat's *Sunday Afternoon on the Island of La Grande Jatte* (1884-86)*,* with its multitude of parasols. Playful and painterly, Stockholder's work explores imaginative territories with provocative results.

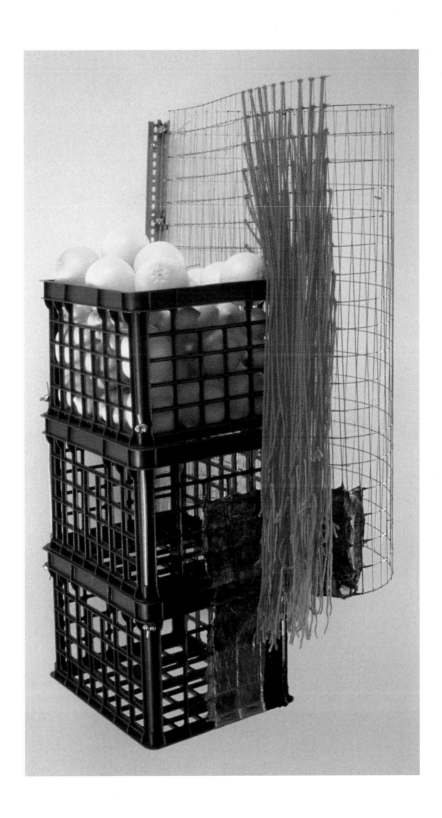

Jessica Stockholder
Shoulder Length, 1995
acrylic paint, purple plastic stacking crates, yarn, papier maché
with sewing pattern paper, hardware, wire mesh, and plastic fruit,
edition of 15, 48 x 25 x 23 inches

George Stoll
by Saeko Baba

George Stoll is an artist from Baltimore who has been living and working in Los Angeles since 1988. Observing and embracing our material culture, he re-creates familiar objects, such as paper towels, rolls of toilet paper, and Tupperware containers and cups, that we use everyday without thinking about them. Because of his reference to mass-production, his works recall those of Andy Warhol, whose endless recreation of popular icons, from Campbell's soup cans to superstars such as Marilyn Monroe and Elvis Presley, were produced with the silkscreen process. Stoll's works however do not depend on cultural irony through mechanical depersonalization and reveal instead the sensitive touch of the hand. Stoll says that he carefully looks at obvious things in order to find out what they are about.[1] This is not unlike the traditional artist's up-close observation of, for example, a flower as an inspiration for a painting.

Like another Pop artist, Claes Oldenburg, Stoll transforms household objects in unexpected ways changing the familiar and functional into the beautiful. Tupperware containers are generally used for preserving leftover food, and when we use them, not really caring about their color and texture, we only think about their size. On the other hand, Stoll's wax Tupperware containers are seductive in color and wonderful to smell. So are his Tupperware cups. He casts them in beeswax and paraffin and stacks the variously colored cups. Creating a rhythmic pattern, the opaque, tapering cylinders form slightly curved columns. By coloring the wax before casting rather than painting over it, the

colors become part of material, and the bright color of the models on which he bases his cups are softened. The various subtle hues contribute a sense of harmony and elicit strong responses in the viewer. According to Bruce Hainley, "While some of his colors beautifully, uncannily replicate Tupperware shades, more often they are like memories of those colors."[2] Evoking memories of childhood when Tupperware may have held our everyday drinks, their delicate auras give us a sense of lightness and warmth. These powerful reactions to color may be independent of shape. As Michael Duncan observed, "Conjuring up the look of stained glass, these works take on a semi-religious quality appropriate for a self-referential, Brady Bunch-loving generation. Stoll's stacks of glasses seem to have been just removed from a '60s kitchen cabinet in preparation for a dreamy kindergarten lawn party."[3] Might Stoll's Tupperware containers be more appropriate for preserving our memories than for leftover food?

Real Tupperware containers are widely used because of their durability. You can heat them up in the microwave. They do not break even if they are dropped on the floor. On the other hand, Stoll's fragile wax cups are sensitive to heat and need careful handling. They remind us to value and handle even tough things with care. The soft texture of Stoll's cups seduces by means of tactile sensations. The substitution of wax for plastic also results in the appearance of Stoll's own touch on the material. This brings to mind Jasper Johns's *Painted Bronze* (1960), a re-creation of two beer cans, in which the artist's thumbprint on the base emphasizes the handmade quality of the work. Just as Johns's work invites comparisons to real beer cans, viewers may wonder why Stoll chose to reproduce rolls of toilet paper or Tupperware cups. But, the questions cease when they realize how beautiful and appealing he has made these common, mass-produced objects, inspired by what's simply around the house. The work is really about still-life painting, in which objects, such as flowers and fruit, are depicted as if available to the hand. A roll of toilet paper, for example, just fits in your hand. His works refer to very accessible things, so that viewers can enjoy the works not only by looking at them but by imagining how each object would feel and respond to touch.

George Stoll,
Untitled, 1995
pine, silk, and colored pencil 11 x 17 x 13 1/2 inches

Notes

1. Interview with the artist, 23 April 1998.

2. Bruce Hainley, "George Stoll," *Artforum* (October 1995): 99.

3. Michael Duncan, "George Stoll," *Art in America* (November 1994): 136.

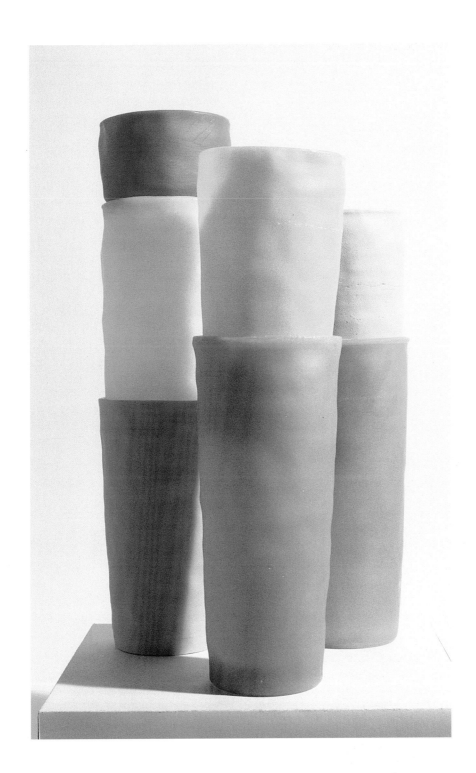

George Stoll
Untitled (7 cup Tupperware sketch), 1995
beeswax, paraffin, and pigment, 11 1/2 x 8 x 7 inches

Daniel Wiener
by Michele Monseau

Daniel Wiener uses compelling juxtapositions of color to define shape and form in the three pieces included in *Chromaform*. Wiener's small scale pieces hang suspended in mid-air by barely visible monofilament as if three bright, awkward, indescribable things had just dropped in for a visit. In most of Wiener's works, color is used to define clusters of information; he uses color to both articulate and unify. This may seem contradictory, but Wiener separates information by defining form through color, then repeats the color to achieve formal balance, a major issue in his work. The formal harmony achieved through color is immediately offset by the awkwardness of the forms. Protrusions, lumps, dangling balls, fungoid growths, and the like dominate the content of these pieces. He says, "I don't believe in the idea of integrity—the structural integrity of Richard Serra's pieces, for instance—where the physical integrity of a sculpture is equal to its moral integrity. That doesn't wash with me, and so I like to add something that sticks out, something that tells you that a willful, fucked up person is making the thing up, that it isn't just happening on its own."[1] Surprisingly, this unbalanced balancing act reinforces the physical energy and impact of these pieces.

Many of Wiener's sculptures make use of repeated elements, one of which is a "barbell" form that is usually suspended on some sort of stalk-like growth. These tiny "weights" seem to teeter and sway, poised to blow whichever way the wind takes them. They are the humorous antithesis of Salvador Dali's crutch-like forms that act as supports in his paintings to prop up various elastic images that seem to have no internal structure: bodies, chins, eye sockets, droopy telephones, and so on. Wiener also makes sculpture that sometimes seems to have no internal structure—marshmallowy (puffy but not hollow) and amoebic, but also otherworldly and shifting. This shifting is largely due to the undulation of the forms and their mutation of one into another. Wiener makes some of his pieces seem blown up, puffed up, ready to pop, but also many are collapsed, flattened, deflated. This metaphoric use of thin air in such a literal way mimics the act of breathing.

Out of Whole Cloth (1997) is reminiscent of a creature of the sea, like a manta-ray with little blue-green balls dangling underneath. Here again, the shape is defined by its color—a delicate pink on one side that echoes the delicate, ethereal shape, and on the underside, a less explainable sour yellow.

Wiener's sculptures elicit desire in the viewer because of their bright, "pop" colors, apparently more influenced by consumer goods and the real world than art and art history. In her article "Thingness and Objecthood," Johanna Drucker says,

> The "ordinary" object from which sculpture has to be distinguished—or with which it is in dialogue—is no longer the bland, uniform, repetitive (and let's face it, boring) forms of industrial material—but rather the eye-seducing, visually distracting stuff of playgrounds, garden supply outlets, and party goods stores. Consumables, all vying for shelf space in the public imagination—these objects are as much a source for artists as are the inherited terms of Modernist sculpture.[2]

A difficult issue in Wiener's body of work is the fact that he makes use of both applied and inherent color, many times in the same piece. When asked if there is any particular philosophy behind this choice, Wiener says, "I make a concerted effort not to think about things like that because it stops you from doing."[3] Wiener's work is resolutely intuitive, nonverbal, and utterly unto itself, which is how he describes the pieces: each one is a fictional world and, as a whole, his body of work is a wonderfully indescribable fictional narrative. As David Pagel insightfully observed, "Wiener's original, inventive art is a delightful melange of the powers of nonverbal communication. Like a hallucinatory game of charades, it demonstrates that the pleasures of naming are not exhausted by what is captured in words, that they spill into the uncertain territory at the borders of language where bodies and naming rub up against one another, shift positions, and continually generate meaning."[4]

Notes

1. Raphael Rubinstein, "Shapes of Things to Come," *Art in America* (November 1995): 98-105.

2. Johanna Drucker, "Thingness and Objecthood," *Sculpture* (April 1997): 21-23.

3. Interview with the artist, 20 April 1998.

4. David Pagel, "Suspending the Limits on Imagination in Sculpture," *Los Angeles Times*, 30 May 1996, F10.

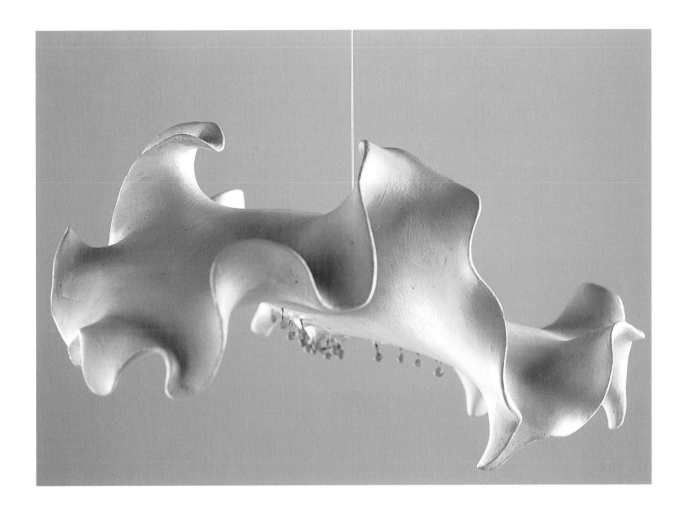

Daniel Wiener
Out of Whole Cloth, 1997
plastic, acrylic, wire, and sculpey, 12 x 6 x 8 inches

Checklist of the Exhibition

Dimensions are in inches unless otherwise specified; height precedes width precedes depth.

Polly Apfelbaum

Bouquet, 1992
crushed stretch velvet and fabric dye, 18 x 15 x 15
courtesy D'Amelio Terras, New York

Champagne (Puddle), 1993
crushed stretch velvet and fabric dye,
dimensions variable
courtesy D'Amelio Terras, New York

Hot Dogs, 1997
velvet, 2 pieces 30 x 20 each, 44 x 30 overall
courtesy D'Amelio Terras, New York

Lillian Ball

Chromasomatic, 1995
platinum based silicone rubber, 9 x 18 x 12
collection of the artist

Chromasomatic, 1998
computer animation, 1:00 min.
courtesy the artist

Cloaca Minima, 1995
platinum based silicone rubber, 8 x 25 x 17
courtesy the artist

Cloaca Minima, 1998
computer animation, 1:00 min.
courtesy the artist

Dogloo, 1994
flexible foam rubber and colorant, 39 x 37 x 32
courtesy the artist

Dogloo, 1998
computer animation, 1:25 min.
courtesy the artist

Chris Finley

Ganoid Ganache x3, 1994
mixed media, dimensions variable
collection of Eileen and Peter Norton, Santa Monica

Match Any Pair..., 1994
mixed media, dimensions variable
courtesy ACME., Los Angeles

Caren Furbeyre

Primary Star Shift I/II, 1998
acrylic, acetate, and metal,
2 tables 30 x 34 x 30 each
courtesy Mark Moore Gallery, Santa Monica

Thomas Glassford

Autogol, 1998
cast resin, 21 1/4 x 30 5/8 x 21 1/4
courtesy the artist and Arena Editions, Guadalajara

Cyber-Gourd Suite, 1994
computer animation, 5 mins.
courtesy the artist

Snake in the Grass, 1997
vinyl, plastic, and zippers, 77 x 159
courtesy the artist

Tutti and Frutti, 1997
glass and lacquer over wood,
2 units 22 x 22 x 22 each
courtesy the artist

John McCracken

Red - Blue, 1998
polyester resin, fiberglass, and plywood,
2 elements 31 x 96 x 10 overall
courtesy the artist

Carlos Mollura

Untitled, 1997
polyurethane film, 70 x 45 x 30
courtesy ACME., Los Angeles

Untitled, 1997
polyurethane film, 70 x 45 x 30
courtesy ACME., Los Angeles

Untitled, 1998
polyurethane film, 72 x 72 x 144
courtesy ACME., Los Angeles

Richard Rezac

Sun and Moon, 1996
painted wood, 4 x 9 x 1 1/2
courtesy Feigen Contemporary, New York

Untitled (92-08), 1992
painted wood, 35 1/4 x 71 1/2 x 11 1/2
collection of Rena Conti and Dr. Ivan Moskowitz,
Brookline, MA

Untitled (93-01), 1993
painted wood, 20 x 22 1/2 x 30 1/2
courtesy Marc Foxx, Los Angeles

Melanie Smith

Instant Atmosphere Ultramix II, 1998
mixed media and fluorescent tube, 59 x 70 3/4
courtesy the artist

Orange Lush VII, 1998
mixed media and acrylic, 51 1/4 x 59
courtesy the artist

Hills Snyder

*The Secret Life of Ants (Jes Grew; Ambassador;
One Eye, One Horn, One Leg; Diva),* 1998
acrylic sheet, birch, and enamel,
97 x 158 x 14 overall
courtesy the artist

Jessica Stockholder

1994
acrylic paint, cement, green nylon umbrella,
aluminum pipe, velvet, green and yellow thread,
purple and orange acrylic yarn, three eye hooks,
and cable with clamp,
43 x 34 x 12 1/2 + 50 inch cable
courtesy the artist and Jay Gorney Modern Art,
New York

Shoulder Length, 1995
acrylic paint, purple plastic stacking crates,
yarn, papier maché with sewing pattern paper,
hardware, wire mesh, and plastic fruit,
edition of 15, 48 x 25 x 23
courtesy the artist and Dia Center for the Arts,
New York

George Stoll

Untitled (Chelsea/Kleenex), 1997
pine and alkyd, 4 1/2 x 12 x 7 1/2
courtesy the artist and Dan Bernier Gallery,
Los Angeles

Untitled (Ivory soap), 1997
lithograph on Juan silk, pine, and acrylic,
3 3/4 x 8 5/8 x 6 3/4
courtesy Cirrus Editions, Los Angeles

Untitled (7 cup Tupperware sketch), 1995
beeswax, paraffin, and pigment, 11 1/2 x 8 x 7
courtesy the artist and Dan Bernier Gallery,
Los Angeles

Daniel Wiener

Epiphyte, 1996
sculpey, wire, and acrylic, 4 x 40 x 4
courtesy Bravin Post Lee, New York

Me Three, 1997
plastic, acrylic, wire, sculpey, and hydrocal,
dimensions variable
courtesy Bravin Post Lee, New York

Out of Whole Cloth, 1997
plastic, acrylic, wire, and sculpey, 12 x 6 x 8
courtesy Bravin Post Lee, New York

Biographies and Bibliographies

Polly Apfelbaum
Born 1955, Abington, PA — Lives and works in New York City, NY

Selected Individual Exhibitions
1998 Kiasma, The Museum of Contemporary Art, Helsinki, Finland (catalogue)
 D'Amelio Terras, New York

1997 Walter/McBean Gallery, San Francisco Art Institute, San Francisco (brochure)
 Realismusstudio der NGBK, Kunstlerhaus Am Acker, Berlin (brochure)

1996 Boesky & Callery Fine Arts, New York

1995 Hirschl & Adler Modern, New York

1994 Project Room, Postmasters Gallery, New York
 Neuberger Museum, Purchase, NY (brochure)
 Residence Secondaire, Paris (catalogue)

1993 Galerie Etienne Ficheroulle, Brussels

1992 Amy Lipton Gallery, New York

1990 Special Projects, P.S.1., Long Island City

Selected Group Exhibitions
1998 *Everyday: 11th Biennale of Sydney*, Sydney, Australia (catalogue)
 Homemade Champagne, Claremont Graduate University, Claremont, CA (catalogue)

1997 *Simple Form*, Henry Art Gallery, University of Washington, Seattle
 Other: The 4th Lyon Biennial of Contemporary Art, Halle Tony Garnier, Lyon, France (catalogue)
 Painting: The Extended Field, Rooseum Center For Contemporary Art, Malmo, Sweden (catalogue)

1996 *Painting: The Extended Field*, Magasin 3, Stockholm Konstall, Stockholm (catalogue)

1995 *Painting Outside Painting: 44th Corcoran Painting Biennial*, Corcoran Museum of Art, Washington, D.C. (catalogue)
 Tampering: Artists and Abstraction Today, High Museum of Art, Atlanta (brochure)

1994 *Sense and Sensibility: Women and Minimalism in the 90s*, Museum of Modern Art, New York (catalogue)

1993 *Empty Dress: Clothing as Surrogate in Recent Art*, ICI, New York (catalogue and tour)
 Future Perfect, Heiligenkreuzerhof, Vienna (catalogue)

Selected Bibliography
Apfelbaum, Polly. "From Fold to Fold." *New Observations* (January-February 1996).
Avgikos, Jan. "Polly Apfelbaum." *Artforum* (Summer 1992).
Bell, Tiffany. "Medley of Signs." *Art in America* (February 1996).
Krane, Susan. *Tampering: Artists and Abstraction Today*. Atlanta: High Museum of Art, 1995.
Lumpkin, Libby. *Vive la Résistance: Polly Apfelbaum's Vanitas of Painting*. Berlin: Realismusstudio der NGBK, 1997.
Mahoney, Robert. *Polly Apfelbaum: Recent Works*. Long Island City: Ramnarine Gallery, 1993.
Pagel, David. "Fortune's Orbit: Polly Apfelbaum's Evocative Arrangements." *Arts Magazine* (January 1991).
_____."Ring-a-Ring-Roses." *Art & Text* (January 1996).
Scott, Andrea. "An Eloquent Silence." *Tema Celeste* (Fall 1992).
Rubinstein, Raphael. "Extended Abstraction." *Art in America* (November 1997).

Lillian Ball
Born 1955, Augusta, ME — Lives and works in New York City, NY

Selected Individual Exhibitions
1998 *Lillian Ball: Support Systems*, Queens Museum of Art at Bulova Corporate Center, Queens (brochure)
1995 Sculpture Center, New York (catalogue)
1992 Rubin Spangle Gallery, New York
1990 Hudson River Museum, Yonkers

Selected Group Exhibitions
1998 *Tick Tick Tick*, Real Art Ways, Hartford, CT
1997 *Object Art/Art Object*, Elga Wimmer Gallery, New York
 Abstracted and Unfixed, Art in General, New York
1996 *Abstract/Real*, Museum of Modern Art, Vienna (catalogue)
 Transformal, Vienna Secession, Vienna (catalogue)
1995 *Lillian Ball, Bernard Frieze, Marcia Hafif*, Chateau de Chazelles, Roanne, France
 The Time is Now, Tony Shafrazi Gallery, New York
 Object Lessons, Massachusetts College of Art, Boston (catalogue)
 BLAST, Cologne Kunstverein, Cologne (catalogue)
1994-95 *Critical Mass,* McKinney Avenue Contemporary, Dallas; Yale University Art Gallery, New Haven (catalogue)
1994 *Bad Girls*, New Museum, New York and Wight Gallery, University of California, Los Angeles (catalogue)
1992 *Getting to kNOw you: Sexual Insurrection and Resistance,* Kunstlerhaus Bethanien, Berlin (catalogue)

1989 Snug Harbor Cultural Center, Staten Island
1986 *Four Pieces by Four Sculptors*, White Columns, New York

Selected Bibliography
Bouligand, Françoise. "En le Matière." *Le Pays*, 28 July 1995.
Carrier, David. "Lillian Ball at Rubin Spangle." *Tema Celeste* (Fall 1992).
Clarkson, David. "Now is the Time." *Flash Art* (October 1995).
Cotter, Holland. "An Era Still Driven to Abstraction." *New York Times*, 11 April 1997.
Damianovic, Maia. "Need to Desire." *Lillian Ball*. New York: Sculpture Center, 1995.
Farver, Jane. *Lillian Ball: Support Systems*. Queens: Queens Museum of Art, 1998.
Greenstein, M.A. "A Conversation with Lillian Ball, Lauren Lesko and Dawn Suggs." *Artweek* (10 March 1994).
Levin, Kim. "Choices." *Village Voice*, 15 March 1995.
Moody, Tom. "Critical Mass." *Art Papers* (Summer 1995).
Myers, Terry. "Minimalism Gets a Life: Lillian Ball's Sculptures and the Real World."*Juni* (Spring 1992).
Rubinstein, Raphael. "Bioinformatica." *Art in America* (July 1995).
Smith, Roberta. "An Esemplastic Shift." *New York Times*, 19 June 1992.
Weissman, Benjamin. "Bad Girl Blues." *Artforum* (May 1994).
Zimmer, William. "Mirror of the Moment, Perhaps a Mild Panic." *New York Times*, 31 May 1998.

Chris Finley
Born 1971, Carmel, CA — Lives and works in Penngrove, CA

Selected Individual Exhibitions
1998 *Level Two*, ACME., Los Angeles
1997 *Level One*, ACME., Santa Monica
1996 ACME., Santa Monica
Jack Tilton Gallery, New York
1995 *Proof*, ACME., Santa Monica
1994 *Cruise Control*, ACME., Santa Monica
The Popsicles are in Bloom, Bravin Post Lee, New York
Double Click, FOOD HOUSE, Santa Monica
1993 *Principle Secret*, FOOD HOUSE, Santa Monica

Selected Group Exhibitions
1997 *118W/24N L.A./USA*, Kunstverein W.A.S., Graz, Austria
Quartoze-20 Los Angeles Artists, Galleri Tommy Lund, Odense, Denmark
Chris Finley, Greg Foley, John Hansel, Laura Parnes, Brownyn Keenan Gallery, New York
1996 *Just Past: The Contemporary in MOCA's Permanent Collection, 1975-1996*, Museum of Contemporary Art, Los Angeles
Defining the Nineties, Museum of Contemporary Art, Miami (catalogue)
1995 *Contact: The 114th Annual Exhibition*, Walter/McBean Gallery, San Francisco Art Institute, San Francisco
Postmarked L.A., P.P.O.W., New York
It's My Life and I'm Going to Change the World, ACME., Santa Monica
1994 *Layered Look*, LAX at the Santa Monica Museum of Art, Santa Monica
Out West and Back East, Santa Monica Museum of Art, Santa Monica
1993 *Germinal Notation*, FOOD HOUSE, Santa Monica
Loose Slots, Temporary Contemporary, Las Vegas

Selected Bibliography
Drohojowska-Philip, Hunter. "Finding Connections to Virtual Reality." *Los Angeles Times*, 12 January 1997.
Duncan, Michael. "L.A. Rising." *Art in America* (December 1994).
Geer, Suvan. "'An Embarrassment of Riches' at the Huntington Beach Art Center." *Artweek* (November 1996).
Grabner, Michelle. "Chris Finley, ACME." *Flash Art* (Summer 1997).
Haines, Gordon. "Chris Finley." *Art issues* (Summer 1998).
Iannaconne, Carmine. "Chris Finley." *Art issues* (January-February 1995).
Knight, Christopher. "Chris Finley Demystifies a High-Tech World." *Los Angeles Times*, 26 January 1994.
Levin, Linda. "Postmarked L.A." *Village Voice*, 11 July 1995.
Pagel, David. "Everyday Art." *Los Angeles Times*, 30 December 1993.
_____. "Pinball Wizard." *Los Angeles Times*, 23 January 1997.
_____. "Visual Stimulation in L.A." *Flash Art* (Summer 1998).
Selwyn, Marc. "Report from Los Angeles." *Flash Art* (June 1995).

Caren Furbeyre
Born 1955, Spokane, WA — Lives and works in Spokane, WA

Selected Individual Exhibitions
1998 Mark Moore Gallery, Santa Monica
1995 Mark Moore Gallery, Santa Monica (brochure)
1993 Mark Moore Gallery, Santa Monica

Selected Group Exhibitions

1995 *Plastic*, Bernard Toale Gallery, Boston

1994 *Clarity*, Mark Moore Gallery, Santa Monica
Detours, Side Street Projects, Santa Monica
Constructed Views, Woodbury University, Burbank, CA
Plane/Structures, Otis College of Art and Design Gallery, Los Angeles (catalogue and tour)

1993 *Technocolor*, Christopher Grimes Gallery, Santa Monica
A Carafe that is a Blind Glass, Weingart Gallery, Occidental College, Los Angeles
Mondo Lot, Robert Berman Gallery, Santa Monica

1990 *The Bradbury Building Show*, Los Angeles Place Projects, Los Angeles
But is it Sculpture?, The Art Store Gallery, Newport Beach, CA
Spatial Inventories, Cerritos University Gallery, Cerritos, CA

1989 *The Unnatural Landscape*, Mount St. Mary's College, Los Angeles

1988 *Salon Show*, Richard Bennett Gallery, Los Angeles
Gallery Artists, Toluca Lake Gallery, Los Angeles

Selected Bibliography

Anderson, Michael. "A Carafe that is a Blind Glass/Sugar and Spice." *Art issues* (May-June 1993).
Clifton, Leigh Ann. "The Works Galleries Merge: New Venue to Open in Santa Monica." *Artweek* (22 April 1993).
Duncan, Michael. "Technocolor at Christopher Grimes Gallery." *Frieze* (November-December 1993).
Gilbert-Rolfe, Jeremy. "Slaves of L.A. and Others." *Artspace* (Summer 1991).
Kandel, Susan. "Breaking Rules: Caren Furbeyre at Mark Moore Gallery." *Los Angeles Times*, 6 May 1993.
_____."Furbeyre: Geometry as a Turning Point." *Los Angeles Times*, 13 February 1995.
Pagel, David. "Caren Furbeyre." *Forum International* (October-November 1993).
_____."Caren Furbeyre at Mark Moore Gallery." *Art issues* (Summer 1995).
_____."In Living Color: Technocolor at Christopher Grimes Gallery." *Los Angeles Times*, 15 April 1993.
_____."Liquid Light: Caren Furbeyre at Mark Moore Gallery." *Los Angeles Times*, 16 January 1998.
Wilson, William. "Plane/Structures at Otis: Enriching Work." *Los Angeles Times*, 19 September 1994.

Thomas Glassford

Born 1963, Laredo, TX — Lives and works in Mexico City, Mexico

Selected Individual Exhibitions

1998 *Neoprene Dreams*, Sala Diaz, San Antonio

1997 *Diversiones, Galería de Arte Contemporáneo*, Mexico City

1996 *The Privilege to Contemplate the Theories of Black Holes*, ExpoArte 96, Guadalajara
Autogol: Oaxaca, Museo de Arte Contemporáneo de Oaxaca, Mexico (brochure)
New Work, Milagros Contemporary Art, San Antonio

1994 *Autogol*, Ex-Convento del Carmen, Guadalajara (catalogue and tour)

1993 *Natural Acts*, Moody Gallery, Houston

1992 *Arteria*, Curare: Espacio Crítico para las Artes, Mexico City

1991 *Laredo*, Laredo Junior College Art Gallery, Laredo, TX
Hydraulics and Mechanics, N. No. 0 Gallery, Dallas

1990 *Obra Nueva*, Estudio Lic. Verdad, Mexico City

Selected Group Exhibitions

1998 *Longitude de Onda*, Museo Alejandro Otero, Caracas, Venezuela

1997 *InSITE97*, San Diego/Tijuana (catalogue)
Our Ideas of the Perfect are so Imperfect, Ramapo College Art Gallery, Mahwah, NJ (brochure)
Asi Está la Cosa, Instalación y Arte Objeto en Latino América, Centro Cultural Arte Contemporáneo, Mexico City
Zona Vedada, Sexta Bienal de la Habana, Havana

1996 *Morph: Meta(morph)osis and Bio(morph)ism in Contemporary Sculpture*, Blue Star Art Space, San Antonio (brochure)
It's My Life and I'm Going to Change the World, ACME., Santa Monica
Colección, Museo Extremeño e Ibeamericano de Arte Contemporáneo, Badajoz, Spain

1994 *Quinta Bienal de La Habana*, Havana

1993 *Texas/Between Two Worlds*, Contemporary Arts Museum, Houston (catalogue and tour)
Lesa Natura, Museo de Arte Moderno, Mexico City
La Frontera/The Border, Museum of Contemporary Art, San Diego/Centro Cultural de la Raza,
 Tijuana (catalogue and tour)

1992 *D.F.: Art from Mexico City*, Blue Star Art Space, San Antonio
Material as Message, Glassell School of Art, Museum of Fine Arts, Houston

Selected Bibliography

Abaroa, Eduardo. "Exposiciones: Francis Alÿs y Thomas Glassford en Oaxaca." *Curare* (Fall 1996).
Colpitt, Frances. "Thomas Glassford at Moody." *Art in America* (September 1993).
Debroise, Olivier. "Thomas Glassford: sus paisajes." *Curare* (Fall 1996).
Emenhiser, Karen., "Thomas Glassford: Hydraulics and Mechanics." *Art Papers* (March-April 1991).
Gambrell, Jamey. "Texas: State of the Art." *Art in America* (March 1987).

Hollander, Kurt. "Crossover Dreams." *Art in America* (May 1998).
_____."Thomas Glassford." *Poliester* (Spring 1993).
Hopwood-Lewis, Steven. "Reviews: Thomas Glassford." *New Art Examiner* (April 1993).
Scott Fox, Lorna. "Reseñas: Diversiones sintéticas." *Curare* (Summer 1997).

John McCracken
Born 1934, Berkeley, CA — Lives and works in Medanales, NM

Selected Individual Exhibitions
1998 *John McCracken: Fluorescent Works*, Galerie Art & Public, Geneva
1997 *Recent Work by John McCracken*, L.A. Louver, Venice, CA
 John McCracken: Recent Works, David Zwirner Gallery, New York
1996 Lisson Gallery, London
1995 *McCracken*, Kunsthalle Basel, Basel, Switzerland (catalogue)
1992 Sonnabend Gallery, New York
1991 Galerie Nordenhake, Stockholm
1986 *Heroic Stance: The Sculpture of John McCracken*, 1965-1986, P.S. 1, Long Island City (catalogue and tour)
1982 Ruth Schaffner Gallery, Santa Barbara
1978 Meghan Williams Gallery, Los Angeles
1969 Galerie Ileana Sonnabend, Paris (catalogue)
 John McCracken: Sculpture, 1965-1969, Art Gallery of Ontario, Toronto (catalogue)
1967 Robert Elkon Gallery, New York
1965 Nicholas Wilder Gallery, Los Angeles

Selected Group Exhibitions
1991 *Carnegie International 1991*, Carnegie Museum of Art, Pittsburgh (catalogue)
1989 *Geometric Abstraction and Minimalism in America*, Solomon R. Guggenheim Museum, New York
 Sculpture: Fulton, Genzken, Gudmundsson, Iglesias, Knoebel, McCracken, Ortwed, Uglow,
 Galerie Nordenhake, Stockholm
1988 *One of a Kind: Contemporary Serial Imagery*, Los Angeles Municipal Art Gallery, Los Angeles (catalogue)
1987 *Colección Sonnabend*, Centro de Arte Reina Sofía, Madrid (catalogue and tour)
1983 *The First Show*, Museum of Contemporary Art, Los Angeles (catalogue)
1978 *California Perspective: Light and Space*, California State University Fullerton, Fullerton
1969 *Art of the Real*, Museum of Modern Art, New York (catalogue and tour)
1967 *A New Aesthetic*, Washington Gallery of Modern Art, Washington, D.C. (catalogue)
 American Sculpture of the Sixties, Los Angeles County Museum of Art, Los Angeles (catalogue and tour)
1966 *Primary Structures*, Jewish Museum, New York (catalogue)

Selected Bibliography
Battcock, Gregory, ed. *Minimal Art: A Critical Anthology*. New York: E.P. Dutton, 1968.
Bickers, Patricia. "UFO Technology: Interview with John McCracken." *Art Monthly* (March 1997).
Brenson, Michael. "Art: John McCracken, 20 Years of Sculpture." *New York Times*, 14 November 1986.
Colpitt, Frances. "Between Two Worlds." *Art in America* (April 1998).
_____. *Minimal Art: The Critical Perspective*. Seattle: University of Washington Press, 1993.
Glueck, Grace. "Thinking Pink with a Plankster." *New York Times*, 23 April 1967
McCracken, John. "John McCracken; Remote Viewing/Psychic Traveling; Mar.-Apr., 1987." *Frieze* (June 1997).
Pagel, David. "John McLaughlin and John McCracken." *Art issues* (December 1990-January 1991).
Schipper, Merle. "Working Between Worlds." *Artweek* (25 April 1987).
Tumlir, Jan. "Reading John McCracken." *Artweek* (February 1998).
Von Meier, Kurt. "American Sculpture of the Sixties." *Art International* (Summer 1969).

Carlos Mollura
Born in 1961, Buenos Aires, Argentina — Lives and works in Los Angeles, CA

Selected Individual Exhibitions
1998 Yerba Buena Center for the Arts, San Francisco
 Ten in One Gallery, Chicago
1997 ACME., Santa Monica
1996 ACME., Santa Monica
 Spanish Box, Santa Barbara
1994 FOOD HOUSE, Santa Monica

Selected Group Exhibitions
1998 *1998 Phoenix Triennial*, Phoenix Art Museum, Phoenix
 The Polka Dot Kitchen, Otis College of Art and Design Gallery, Los Angeles (catalogue)
 Love at the End of the Tunnel, or the Beginning of a Smart New Day, Center on Contemporary Art, Seattle (catalogue)

1997 *Elusive Paradise: Los Angeles Art from the Permanent Collection*, Museum of Contemporary Art, Los Angeles
ACME., Santa Monica
1997 Biennial, Orange County Museum of Art, Newport Beach, CA (catalogue)
Working Out the Kinks, Kunstlerhaus Bethanien, Berlin
Ten Los Angeles Artists, Steven Wirtz Gallery, San Francisco

1996 *Los Angeles Visits P-House and Three Day Weekend*, Tokyo
Space Space, Post, Los Angeles
Just Past: The Contemporary in MOCA's Permanent Collection, 1975-1996, Museum of Contemporary Art, Los Angeles
ACME., Santa Monica
Eros Travel Company, Three Day Weekend (Abroad), Berlin, Hamburg, Stuttgart, and Vienna
Affairs, Institute for Contemporary Art, Vienna

Selected Bibliography

Brooks, Rosetta. "Carlos Mollura at ACME." *LA Weekly*, 14-20 March 1997.
Curtis, Cathy. "Inextricable References." *Los Angeles Times* (Orange County Edition), 6 May 1997.
Demetre, Jim. "End of the World? I Feel Fine." *Seattle Weekly*, 12 February 1998.
Haines, Gordon. "Carlos Mollura at ACME." *Art issues* (Summer 1997).
Helfand, Glen. "Ten Los Angeles Artists." *San Francisco Bay Guardian*, 19 February 1997.
Kugelman, Kerry. "Carlos Mollura at ACME." *Artweek* (April 1996).
Pagel, David. "Buoyant." *Los Angeles Times*, 21 February 1997.
Servetar, Stuart. "Galleries Downtown." *New York Press*, 28 June 1995.
Walsh, Daniella. "Where All Things Old Are New Again." *Orange County Register*, 11 May 1997.
Wiens, Ann. "Ten in One Gallery." *Chicago's NEW CITY*, 5 March 1998.

Richard Rezac

Born 1952, Lincoln, NE — Lives and works in Chicago, IL

Selected Individual Exhibitions

1998 Feigen Contemporary, New York

1997 Marc Foxx, Santa Monica

1996 Feigen, Inc., Chicago

1995 Feature, New York
Richard Rezac: Shelf Sculptures 1982-1994, I Space Gallery, Chicago (brochure)

1993 Feature, New York
Richard Rezac: Sculpture 1987-1992, Cedar Rapids Museum of Art, Cedar Rapids, IA
Susanne Hilberry Gallery, Birmingham, MI

1990 *Options 38: Richard Rezac*, Museum of Contemporary Art, Chicago (brochure)

1985 Portland Center for the Visual Arts, Portland, OR

Selected Group Exhibitions

1998 *Thomas Nozkowski and Richard Rezac*, TBA Exhibition Space, Chicago

1996 *Art in Chicago: 1945-1995*, Museum of Contemporary Art, Chicago (catalogue)

1995 *Resonance*, Roland Gibson Gallery, State University of New York, Potsdam (catalogue)
The Friendly Village, Layton Gallery, Milwaukee Institute of Art and Design, Milwaukee

1994 *Sculpture on the Wall*, Center Gallery, Center for Creative Studies, Detroit

1993 *A Sequence of Forms: Sculpture by Illinois Artists*, Chicago Cultural Center and State of Illinois Art Gallery, Chicago
Points of Reference: Contemporary Abstraction, Fine Arts Gallery, Indiana University, Bloomington

1990 *Grounded: Sculpture on the Floor*, University of Michigan Museum of Art, Ann Arbor (catalogue)

1986 *Emerging Sculptors 1986*, The Sculpture Center, New York (catalogue)

Selected Bibliography

Artner, Alan. "Rezac's Uncanny Takes on Japanese Sources Stand Out." *Chicago Tribune*, 20 September 1991
_____. "Richard Rezac Gives His Sculptures Plenty of Shelf Life." *Chicago Tribune*, 19 May 1995
Hixson, Kathryn. "Chicago in Review." *Arts* (December 1991).
Iannaccone, Carmine. "Richard Rezac at Marc Foxx." *Art issues* (Summer 1995).
Johnson, Ken. "Richard Rezac at Loughelton." *Art in America* (September 1988).
Kirshner, Judith Russi. "Richard Rezac at Feigen, Inc." *Artforum* (January 1997).
Melrod, George. "Richard Rezac at Feature, Inc." *Sculpture* (March-April 1994).
Morgan, Ann Lee. "Richard Rezac at Feature." *New Art Examiner* (January 1988).
Pagel, David. "Richard Rezac at Marc Foxx." *Los Angeles Times*, 30 March 1995.
Reijn, Els. "Richard Rezac at Shoshana Wayne." *Artweek* (14 February 1991).
Yood, James. "Richard Rezac." *Artforum* (May 1990).

Melanie Smith
Born 1965, Dorset, England — Lives and works in Mexico City, Mexico

Selected Solo Exhibitions
1997 *Orange Lush*, Instituto Anglo-Mexicano de Cultura, A.C., Mexico City (catalogue)
1996 Striking Distance, Los Angeles
 Galería O.M.R., Mexico City
 Project Room, Randolph Street Gallery, Chicago
1994 Galería O.M.R., Mexico City
1992 L'Escaut, Brussels
1989 Salón de los Aztecas, Mexico City

Selected Group Exhibitions
1998 *7 + 1 Mujeres Artistas*, Museum of Modern Art, Mexico City
1997 *México Ahora: Punto de Partida/Mexico Now: Point of Departure*, Riffe Gallery, Columbus, OH (catalogue and tour)
 The Conceptual Trend: Six Artists from Mexico City, El Museo del Barrio, New York
 Cultural Hybrids, Oboro Gallery, Montreal
 InSite97, San Diego/Tijuana (catalogue)
 Inauthentic: Made in Mexico, ExpoArte, Guadalajara
 Life's Little Necessities: The Second Biennale of Johannesburg, Cape Town (catalogue)
1995 *Planton en el Zocalo*, Temistocles 44, Mexico City
 It's My Life and I'm Going to Change the World, ACME., Santa Monica
 Par Avion, L.A.C.E., Los Angeles
1994 *Neo*, Galería O.M.R., Mexico City
 Las Nuevas Majas, Otis College of Art and Design Gallery, Los Angeles
 Arte Mexicano: Imagenes en el siglo de sida, CU Art, University of Colorado, Boulder
1992 *D.F.: Art from Mexico City*, Blue Star Art Space, San Antonio

Selected Bibliography
Anastas, Rhea. "The Conceptual Trend: Six Artists from Mexico City." *Art Nexus* (April-June 1997).
Debroise, Olivier. "Un Nuevo Contrato." *Curare Bulletin* (Spring 1996).
Gallo, Ruben. "Review." *Flash Art* (Spring 1998).
Guerra, Maria. "D.F.: Art from Mexico City." *Poliester* (Fall 1991).
Hollander, Kurt. "Marcas, at the Galeria de Arte Contemporáneo." *Mandorla Magazine* (Fall 1992).
Jusidman, Yishae. "Las Nuevas Majas." *Art issues* (September-October 1994).
Knight, Christopher. "Independent Spirit Lives on in Majas." *Los Angeles Times*, 16 July 1994.
MacMasters, Merry. "En la Punta de me Lengua de Melanie Smith." *El Nacional*, 27 July 1994.
Pagel, David. "A Life of Hunting Down Perfectly Quirky Bargains." *Los Angeles Times*, 1 June 1995.
Ross, Charlene. "Working Space." *Artweek* (21 July 1994).
Sanchez, Osvaldo. "Recipientes y Protuberencias." *La Reforma*, 25 August 1994.

Hills Snyder
Born 1950, Lubbock, TX — Lives in Helotes and works in San Antonio, TX

Selected Individual Exhibitions
1998 *Neil Diamond's Greatest Hits*, Sala Diaz, San Antonio
 Gloville, Casino Luxembourg, Forum d'Art Contemporain, Luxembourg (catalogue)
 Suede Sandbox, DiverseWorks subspace, Houston
1997 *Representative Material*, Rrose Amarillo, San Antonio
1996 *Hand Not Hand*, The Hudson (Show)Room, ArtPace: A Foundation for Contemporary Art I San Antonio;
 Austin Museum of Art, Austin
1989 Yellowstone Art Center, Billings, MT
1987 *June Rise Ramble*, Custer County Art Center, Miles City, MT (brochure)
 Garage Optimism, Patrick Gallery, Austin
1985 *Hills Snyder: Constructions and Drawings*, Tyler Museum of Art, Tyler, TX

Selected Group Exhibitions
1997 *Space*, Arlington Museum of Art, Arlington, TX (catalogue)
1996 *Double Trouble: Mirrors/Pairs/Twins/Lovers*, Blue Star Art Space, San Antonio
1995 *The Home Show*, UTSA Art Gallery, University of Texas, San Antonio (brochure)
1990 *Some Recent Sculpture*, Space, Los Angeles
1989 *A Century of Sculpture In Texas, 1889-1989*, Archer M. Huntington Gallery, University of Texas,
 Austin (catalogue and tour)
1985 *John Hernandez, Hills Snyder, Randy Twaddle*, Patrick Gallery, Austin
1987 *Third Coast Review: A Look at Art in Texas*, Aspen Art Museum, Aspen, CO (catalogue and tour)
1986 *Scale*, Missoula Museum of The Arts, Missoula, MT
1984 *Constructed Image/Constructed Object*, Alternative Museum, New York
1983 *Sculpture on the Wall*, San Antonio Art Institute, San Antonio

Selected Bibliography
 Cohen, Rebecca. "Hand Not Hand." *Austin Chronicle*, 25 October 1996.
 Colpitt, Frances. "Hills Snyder at The Austin Museum of Art," *Art In America* (February 1997).
 _____."The Road to Gloville." *Gloville*. Luxembourg: Casino Luxembourg, Forum d'Art Contemporain, 1998.
 Friis-Hansen, Dana. *Double Trouble: Mirrors/Pairs/Twins/Lovers*. San Antonio: Blue Star Art Space, 1996.
 Kutner, Janet. "Hills Snyder." *ARTnews* (November 1985).
 McConnell, Gordon. "Worlds Within Worlds: The Art of Hills Snyder." *June Rise Ramble*. Miles City, MT: Custer County Art Center, 1987.
 Merry, Bejou. "Pshychedelic Artesia." *Austin Chronicle*, 29 October 1982
 Reese, Becky Duvall. "Experiment and Idea in Contemporary Texas Sculpture." *A Century of Sculpture in Texas*. Austin: Archer M. Huntington Gallery, University of Texas, 1989.
 Storr, Robert. "Texas Shuffle," *New American Talent*. Austin: Texas Fine Arts Association, 1997.
 Torregrossa, Bernice. "Spellbinding Spaces." *Austin American-Statesman*, 8 August 1985.

Jessica Stockholder
 Born 1959, Seattle, WA — Lives and works in Brooklyn, NY

Selected Individual Exhibitions

1997 Kunstnernes Hus, Oslo
 Contemporary Fine Arts, Berlin

1996 *Bowtied in the Middle*, Tom Solomon's Garage, Los Angeles

1995 *Your Skin in this Weather Bourne Eye-Threads & Swollen Perfume*, Dia Center for the Arts, New York (catalogue)
 Jay Gorney Modern Art, New York
 Sweet for Three Oranges, Sala Montcada de la Fundacion "la Caixa," Barcelona (catalogue)

1994 *Pink Lady*, Weatherspoon Art Gallery, The University of North Carolina, Greensboro (catalogue)

1993 *Edge of Hothouse Glass*, Galerie des Arénes, Carre d'Art, Musée d'Art Contemporain de Nimes, Nimes, France (catalogue)

1991 Daniel Weinberg Gallery, Santa Monica

1987 *It's not over 'til the fat lady sings*, Contemporary Art Gallery, Vancouver (catalogue)

Selected Group Exhibitions

1997 *Painting: The Extended Field*, Rooseum Center for Contemporary Art, Malmo, Sweden (catalogue)

1995 *Collectie Prasentatie Moderne Kunst*, Centraal Museum Utrecht, The Netherlands
 Painting Outside Painting: 44th Biennial Exhibition of Contemporary American Painting, The Corcoran Gallery of Art, Washington, D.C. (catalogue)
 Color in Space: Pictorialism in Contemporary Sculpture, David Winton Bell Gallery, List Art Center, Brown University, Providence, RI (catalogue)

1994 *Pittura-Immedia: Malerei in den 90er Jahren*, Neue Galerie am Landesmuseum Joanneum, Graz, Austria

1993 *As Long as It Lasts*, Witte de With, Rotterdam

1991 *1991 Biennial*, Whitney Museum of American Art, New York (catalogue)
 Awards in the Visual Arts 10, Southeastern Center for Contemporary Art, Winston-Salem (catalogue and tour)
 Contingent Realms, Whitney Museum of American Art at Equitable Center, New York
 Selections From the Artists File, Artists Space, New York (catalogue)

1983 *Installation in My Father's Backyard*, private residence, Vancouver

Selected Bibliography
 Bankowsky, Jack. "The Obligatory Bed Piece." *Artforum* (October 1990).
 Berkman, Robert. "Pulling Matisse Off the Wall." *Linewaters' Gazette* (1996).
 Butler, Connie. "Terrible Beauty and the Enormity of Space." *Art & Text* (September 1993).
 Ottmann, Klaus. "Interview with Jessica Stockholder." *Tema Celeste* (Spring-Summer 1991).
 Princenthal, Nancy. "Jessica Stockholder: Reinventing the Real." *Art & Text* (October 1995).
 Rubinstein, Raphael. "Shapes of Things to Come." *Art in America* (November 1995).
 Schwabsky, Barry; Lynne Tillman; Lynne Cooke. *Jessica Stockholder*. London: Phaidon, 1994.
 Sichel, Berta. "Undomesticated Still Lifes: The Order and Disorder of Jessica Stockholder." *Balcon* (January 1991).
 Stockholder, Jessica. "Figure Ground Relations, Part 1: Catcher's Hollow," and "Part 2: Self Portrait." *Witte de With-Cahier #1* (October 1993).
 _____. "Parallel Parking." *Turn-of-the-Century Magazine* (Spring 1993).
 Troncy, Eric. "Painting from All Over to All Round: Lauren Szold and Jessica Stockholder Start Gigging." *Flash Art* (January-February 1994).

George Stoll
 Born 1954, Baltimore, MD — Lives and works in Los Angeles, CA

Selected Individual Exhibitions

1997 *New Sculpture, Paintings and Drawings*, Morris Healy Gallery, New York

1996 *Snowflakes*, Dan Bernier Gallery, Santa Monica

1995 *161 Tumblers 2 Ways*, Daniel Weinberg Gallery, San Francisco
 Toilet Paper, Dan Bernier Gallery, Santa Monica
 Sculpture, Morris Healy Gallery, New York

1994 *Newspaper & Plywood Drawings*, *Paper Towel Paintings*, *Fast Food Wrappers*, TRI Gallery, Los Angeles
 Tupperware, A/B Gallery, Los Angeles

Selected Group Exhibitions

1998 *Love at the End of the Tunnel, or the Beginning of a Smart New Day*, Center on Contemporary Art, Seattle (catalogue)

1997 *LA Pop in the Nineties, or How I Stopped Worrying and Learned to Love the Bomb*, Center on
 Contemporary Art, Seattle
 Tabletops: Morandi's Still Lifes to Mapplethorpe's Flower Studies, California Center for the Arts,
 Escondido, CA (catalogue)
 New Work: Drawings Today, San Francisco Museum of Modern Art, San Francisco

1996 *Happy Days: Mark Bennett and George Stoll*, The Contemporary Art Center, Cincinnati
 An Embarrassment Of Riches, Huntington Beach Art Center, Huntington Beach, CA (catalogue)
 Real Goods, Art Manhattan, Manhattan Beach, CA
 Menu Du Jour, Silverstein Gallery, New York

1995 *Selections Spring '95*, The Drawing Center, New York
 Soft Touch, Newspace, Los Angeles
 Group Show, Daniel Weinberg Gallery, San Francisco
 Group Show, Bravin Post Lee, New York

1994 *Hooked On a Feeling*, Kohn Turner Gallery, Los Angeles

Selected Bibliography

Anderson, Michael. "George Stoll." *Art issues* (May-June 1994).
Darling, Michael. "An Insistent Whimsy." *Artweek* (18 August 1994).
Duncan, Michael. "George Stoll." *Art in America* (November 1994).
_____. "L.A. Rising." *Art in America* (December 1994).
Geer, Suvan. "'An Embarrassment of Riches' at the Huntington Beach Art Center." *Artweek* (November 1996).
Hainley, Bruce. "George Stoll." *Artforum* (October 1995).
Kastner, Jeffrey. "Stuffed." *Art Monthly* (July-August 1995).
Koestenbaum, Wayne. "Top Ten x 12: The Year in Review." *Artforum* (December 1997).
Nolan, Tim. "George Stoll." *New Art Examiner* (February 1997).
Selwyn, Marc. "Report from L.A." *Flash Art* (May-June 1995).

Daniel Wiener

Born 1955, Cambridge, MA — Lives and works in New York City, NY

Selected Individual Exhibitions

1998 ACME., Los Angeles
 Noirhomme & Velge, Brussels
 Vadstrup & Bie, Copenhagen

1997 Barbara Farber, Amsterdam
 Angles Gallery, Los Angeles

1996 Bravin Post Lee, New York
 McKinney Avenue Contemporary, Dallas

1995 Project Room, Holly Solomon Gallery, New York

1993 Germans Van Eck, New York

1992 Dorothy Goldeen Gallery, Los Angeles

Selected Group Exhibitions

1997 *Sculptural Imagery*, The Work Space, New York
 James Schmidtt Contemporary, St. Louis

1996 *Currents in Contemporary Art*, Christies East, New York
 Transformal, Vienna Secession, Vienna (catalogue)

1995 *Color: Sign, System, Sensibility*, Stark Gallery, New York

1994 Santa Monica Museum of Art, Santa Monica
 Jeanne Silverthorne, Matthew Weinstein, Daniel Wiener, Lutz Teutloff Modern Art, Cologne

1993 *Post-Dialectical Index*, Fiorella Lalumia Studio, Milan (catalogue)

1992 *A Marked Difference*, 7 Arti et Amicitiae, Amsterdam (catalogue)
 In Praise of Folly, John Michael Kohler Arts Center, Sheboygan, WI (catalogue)

Selected Bibliography

Drucker, Johanna. "Thingness and Objecthood." *Sculpture* (April 1997).
Melrod, George. "Daniel Wiener at Germans Van Eck." *Art in America* (February 1994).
Moody, Tom. "Daniel Wiener at Bravin Post Lee." *New Art Examiner* (May 1996).
Pagel, David. "Suspending the Limits on Imagination in Sculpture." *Los Angeles Times*, 30 May 1996.
Pollack, Barbara. "Leaping Off the Pedestal." *ARTnews* (June 1998)
Rubinstein, Raphael. "Fabian Marcaccio and Daniel Wiener at John Post Lee." *Flash Art* (Summer 1992).
_____. "Shapes of Things to Come." *Art in America* (November 1995).
Sillman, Amy. "Daniel Wiener at Bravin Post Lee Gallery." *Thingreviews* (Microsoft Internet Explorer, 31 March 1996).